MASTERING **EXPOSURE**

THE DEFINITIVE GUIDE FOR PHOTOGRAPHERS

DAVID TAYLOR

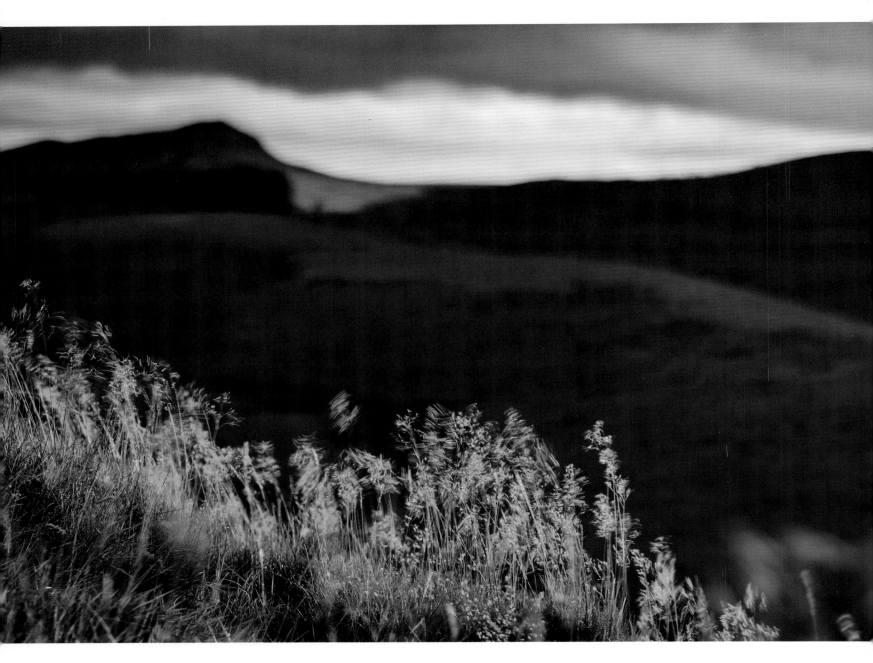

Above: A thorough understanding of exposure—and how it can be used creatively—is important if you want to progress as a photographer. This is true regardless of what your favorite genre of photography happens to be.

Focal length: 100mm

Aperture: f/4

Shutter speed: 1/20 sec.

ISO: 100

MASTERING **EXPOSURE**

THE DEFINITIVE GUIDE FOR PHOTOGRAPHERS

DAVID TAYLOR

AMMONITE
PRESS

First published 2016 by
Ammonite Press
an imprint of AE Publications Ltd
166 High Street, Lewes, East Sussex, BN7 1XU, United Kingdom

ISBN 978-1-78145-205-9

British Library Cataloging in Publication Data: A catalog record of this
book is available from the British Library.

Editor: Chris Gatcum
Publisher: Jason Hook
Designer: Robin Shields

Typeface: Helvetica Neue
Color reproduction by GMC Reprographics
Printed in Turkey

Contents

Introduction

There are certain subjects that at first glance appear dauntingly arcane. When you examine the subject more closely, the mystery deepens, and you begin to wonder how anyone could possibly grasp even the simplest details, never mind master the subject.

Photographic exposure is one of those subjects. Look at a camera body and lens and there are buttons inscribed with "±" and "AEL," and dials that, when turned, alter numbers in a seemingly illogical way. It's no wonder that some people stick with automatic shooting modes that let the camera do all the work (even if the camera occasionally makes a mistake and produces images that are too dark or too light).

However, understanding—and mastering— exposure isn't impossible. Being able to control your exposures is an enormously satisfying skill, and one that will make your photography more enjoyable and consistently successful. Once a few basic concepts have been grasped, even those illogical number sequences make perfect sense: this book is a guide to these exposure fundamentals, and more besides.

Right: One part of mastering exposure is anticipating when the lighting conditions may prove problematic. Another part is knowing what action to take to allow a camera to record a technically successful shot. This image, with bright reflective surfaces, required negative exposure compensation to record detail in the highlights.

Focal length: 55mm

Aperture: f/4

Shutter speed: 1/40 sec.

ISO: 400

EXIF	
Dimensions	4912 x 7360
Cropped	4405 x 6601
Exposure	$^1/_{3000}$ sec at f / 2.8
Exposure Bias	½ EV
Flash	Did not fire
Exposure Program	Aperture priority
Metering Mode	Pattern
ISO Speed Rating	ISO 400
Focal Length	155 mm
Focal Length 35mm	155 mm
Lens	80.0-200.0 mm f/2.8
Date Time Original	13/08/2015 14:12:06
Date Time Digitized	13/08/2015 14:12:06
Date Time	13/08/2015 17:43:10
Make	NIKON CORPORATION
Model	NIKON D800

Left & Above: Shooting information—including exposure settings—is stored in the EXIF section of the image metadata. Information added after shooting, such as copyright details, is stored in the block of information known as IPTC.

Experimentation

The great thing about digital photography is that once you've bought your camera, each photograph you take is essentially free. This means that an understanding of how your camera works—and its latitude in various exposure situations—can be achieved relatively quickly.

The key to understanding your camera is experimentation and a willingness to try new techniques. However, experimentation is only worthwhile if it's followed by careful analysis of the images that you shoot. When analyzing your images you should look carefully at what went right, but also try and determine if anything went wrong (invariably there are always aspects to an image that could have been improved). Once you've been through this process it's important to apply any lessons you learn to subsequent photography sessions.

When shooting film, there was no way to store exposure information, other than to write it down on paper. This was laborious and impossible when shooting quickly. Fortunately, digital cameras append a wide range of shooting data to every image you shoot, including exposure information such as the aperture, shutter speed, and ISO settings. This metadata can be viewed either in-camera, during playback, or via image-editing software on your computer. This is a valuable resource when it comes to mastering exposure, so studying it should be considered an important part of the learning process.

Above: During a long exposure there's no real reason to leave your camera passively recording a scene. Moving the camera or—as here—slowly turning the zoom ring, can create unusual and striking effects that would be difficult to replicate in postproduction.

Focal length: 125mm
Aperture: f/8
Shutter speed: 30 seconds
ISO: 100

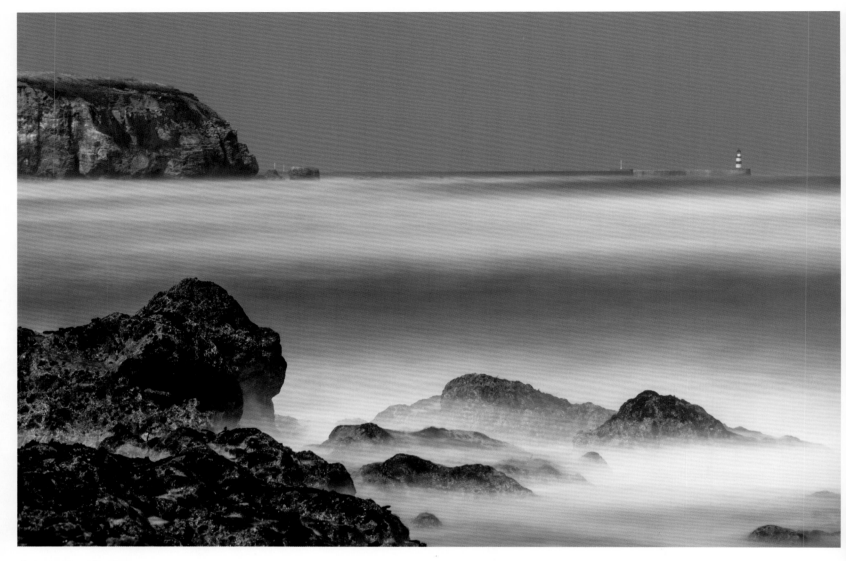

Approaches

There are two approaches to exposure when shooting digitally. The first is to shoot so that the exposure and other factors, such as white balance, are as technically correct as possible in-camera. This approach is particularly important when shooting JPEGs, as there is much less scope for postproduction adjustment than when shooting Raw files (see page 68).

The second approach is to shoot so that there is the greatest possible latitude for postproduction work, without loss of image quality. This approach takes in techniques such as ETTR (see page 106) and HDR (see page 164), and is generally more suitable when shooting Raw. However, mastering exposure is partly about knowing which approach is the correct one to take.

This choice is just one of many that you'll face as you shoot. As you'll see, exposing photographs successfully is a matter of making decisions at every stage of the shooting process. Choice—when there are ramifications that follow a particular option—can be daunting. If you choose the wrong option at any stage, you may find yourself backed into a corner that imposes limits on what can (and can't) be achieved subsequently. Fortunately, there is an underlying logic to exposure that can, with patience, be learned, applied, and mastered.

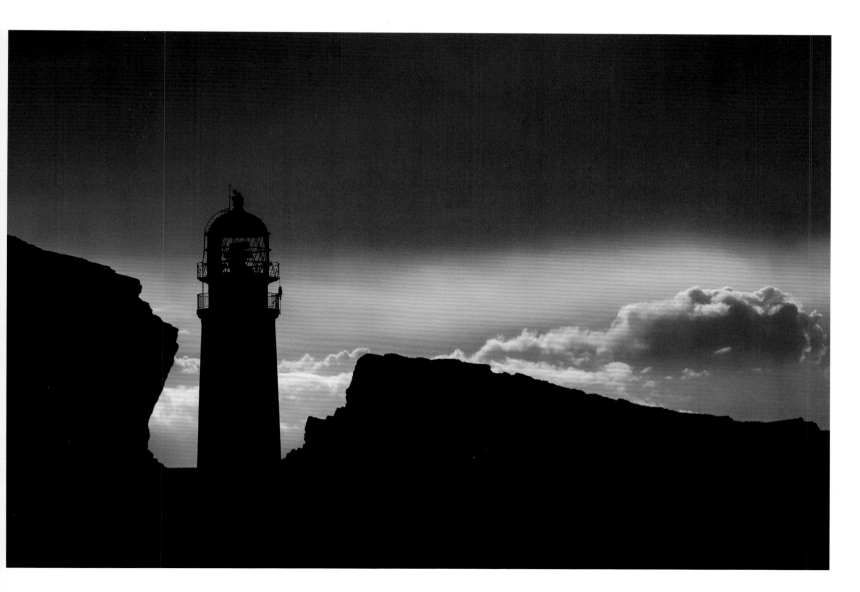

Left: All postproduction work is a form of destruction; a gradual whittling away of the image data captured by the camera at the time of shooting. Exposing so that you maximize the usable image data will give you a higher level to start from. This means making the right choices all the way through the shooting process.

Focal length: 200mm

Aperture: f/20

Shutter speed: 20 sec. (with 10-stop ND filter)

ISO: 100

Above: A similar subject to that opposite, but with an entirely different approach. Exposure is a creative act that is separate from, but also connected to, composition. In this instance, slight underexposure (which was increased in postproduction) has added a moody, somber feel to the shot. This helps to reproduce the stormy, brooding quality of the weather experienced when I was at the location.

Focal length: 100mm

Aperture: f/8

Shutter speed: 1/640 sec.

ISO: 100

Chapter 1
Equipment

Before you can start to master exposure you need a camera and—unless you're shooting pinhole images—a lens. Cameras and lenses vary in their sophistication and the ease with which exposure adjustments can be made. Ideally, the photographic equipment you use should allow you full control over all aspects of shooting. Choosing the equipment you buy should therefore be a process of careful deliberation over features, and whether they will serve your needs as those needs inevitably alter over time.

PINHOLE CAMERAS
A pinhole camera does not have a lens. Images are sharp (or at least relatively sharp) due to the tiny aperture that allows light to reach the sensor. This is equivalent to using a very small aperture to increase depth of field (see page 39). Digital system cameras can be turned into pinhole cameras with third-party attachments similar to a standard body cap.

Right: Although it's possible to shoot with only a camera and lens there are other items of equipment that will prove invaluable, depending on your style of shooting. This image, photographed near sunset, would have been much harder to achieve without the use of a tripod and lens hood.

Focal length: 60mm lens

Aperture: f/16

Shutter speed: 1/6 sec.

ISO: 100

Cameras

Regardless of its sophistication, a camera is essentially a box that controls the amount of light that reaches a light-sensitive surface inside. This light-sensitive surface is either a sheet of glass or film coated in an emulsion of silver salts, or a digital sensor.

Camera Types

Mastering exposure requires taking control of all aspects of making an image. What differentiates camera models is how much control they allow you to take. Cameras can be broadly split into two types: system and non-system cameras.

A system camera is one that allows you to change lenses, and also has the facility to accept other accessories, such as remote releases and flash units. Digital Single Lens Reflex (or DSLR) and mirrorless cameras are the two most common types of digital system cameras.

Non-system cameras are more self-contained and offer very little scope for expansion of their capabilities. This type of camera includes those found in cellphones (although smartphones allow you to use apps to enhance the capabilities of their built-in cameras) and compact cameras that, as the name suggests, are small, easily pocketable cameras. Non-system cameras don't allow you to change the lens, but they often have a wide focal length range to compensate, making this less of a restriction than you'd expect. They also generally don't have the connections necessary for additional accessories, although most feature a small built-in flash.

As a general rule, system cameras enable you to take more control over the exposure, and make it easier to set functions such as aperture and shutter speed. Non-system cameras often rely more heavily on automated exposure systems that preclude any chance of changing how an image is exposed. Or, if exposure can be controlled, they bury the necessary settings in menus, rather than making the controls easily accessible as exterior buttons or dials (this is often due to the small size of such cameras, which restricts the space available for physical controls).

Below: The relative sizes of a typical compact camera (Nikon Coolpix S7000); a mirrorless camera (Olympus OM-D M5 II); and a full-frame DSLR (Canon EOS 5Ds).
© Nikon, Olympus, and Canon

DSLR & Mirrorless Cameras

The major difference between a DSLR and a mirrorless camera is the viewfinder. Images are composed by looking through an optical viewfinder when using a DSLR, while mirrorless cameras rely on an electronic viewfinder (EVF), or when there is no built-in viewfinder, the rear LCD screen. Both systems have their advantages and disadvantages, and which you prefer depends largely on how easily you can overlook their drawbacks.

The major appeal of an optical viewfinder (as in a DSLR) is that you see a crisp image projected through the lens straight to your eye, without any electronic processing; the light from the lens is directed via a reflex mirror and pentaprism (it's the lack of a reflex mirror that gives a mirrorless camera its name). At the moment of exposure, the mirror is swung up out of the way to reveal the shutter and sensor behind, temporarily blanking out the viewfinder in the process. Once the exposure has been made, the mirror returns to its original position so you can see through the viewfinder once more.

One disadvantage with this system is that you can't see how a scene's tonal range will affect your exposure until you shoot and review the photograph. It's also impossible to view useful exposure tools such as a live histogram through an optical viewfinder.

In contrast, the EVF of a mirrorless camera displays a feed directly from the camera's sensor. This means that any problems with contrast or exposure can be seen immediately and dealt with before shooting (helped by the ability to view histograms and options such as "zebras," which we will explore later).

However, the usefulness of an EVF is largely determined by the technology that underpins it. One important aspect of an EVF is its resolution in terms of pixel density; the lower the number of pixels in the display, the less crisp it will be. This can make it harder to view fine detail, which can be critically important when using manual focus. EVFs can also suffer—to a greater or lesser degree—from a problem known as "lag." This is because EVFs don't instantly update, so the display sometimes needs to "catch up" when a camera is moved quickly, or when shooting fast action.

RANGEFINDERS

A third type of system camera is the rangefinder, although these have arguably been superseded by mirrorless cameras. Although this type of camera features an optical viewfinder, it differs from the DSLR in that the viewfinder image isn't derived from the fitted lens. Instead, frame lines within the viewfinder provide a guide to composition and the angle of view of the fitted lens. The advantage of a rangefinder over a DSLR is that the viewfinder is consistently bright, as it isn't affected by the maximum aperture of the fitted lens. However, as you don't see directly through the lens, it's harder to use certain accessories (such as filters) accurately.

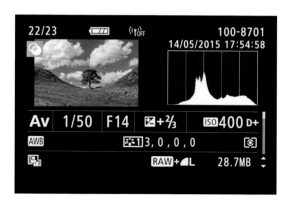

Left: If you look through an optical viewfinder, you miss out on exposure tools such as the image histogram. This means you can only be sure that the exposure is correct after shooting, during image review.

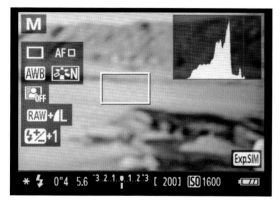

Left: Modern DSLRs offer a live image feed from the sensor on the rear LCD screen, which is known as Live View. This effectively mimics the way that a mirrorless camera works, by swinging the camera's reflex mirror out of the way. Live View has its downsides, though: the main problem is that autofocus speed tends to be sluggish compared to using the viewfinder. However, Live View is a good way to assess an exposure before shooting and it also helps cure problems such as mirror slap (see page 65).

Lenses

A lens focuses the light that falls onto the sensor to form the final image. The most important aspect of a lens is its focal length, which in combination with the size of a camera's sensor determines the lens' angle of view. Prime lenses have a fixed focal length, while zoom lenses are designed to let you vary the focal length.

Focal Length

Once the size of a camera's sensor has been taken into account, focal length tells you the angle of view that can be captured by the lens. The technical definition of focal length is that it's the distance from the optical center of the lens to the focal plane when a subject at a distance of "infinity" is in focus. Focal length is represented by a measurement shown in mm, such as 24mm or 180mm.

Angle of view is the angular extent of an image projected by a lens, either as a horizontal, vertical, or—more commonly—diagonal measurement. However, as already mentioned, the size of the sensor inside a camera influences the angle of view as well: the smaller the sensor, the narrower the angle of view of a lens at a given focal length.

The standard by which lenses are compared is the full-frame sensor, which is the same size as a 35mm film frame (36 x 24mm). However,

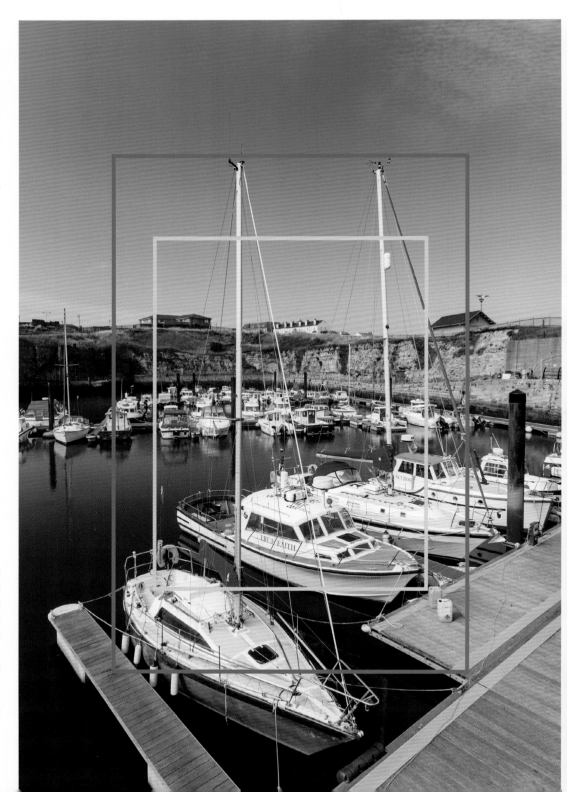

Right: This harbor scene was shot using a 20mm lens fitted to a full-frame camera. If the same lens were fitted to an APS-C camera, the angle of view would be reduced to the outer green box. On a Micro Four Thirds camera the angle of view would be smaller still and restricted to the inner pink box.

Focal length: 20mm

Aperture: f/11

Shutter speed: 1/60 sec.

ISO: 200

cameras fitted with APS-C-sized sensors are more common. These sensors are 1.5x or 1.6x smaller than a full-frame sensor (measuring approximately 23.5 x 15.6mm or 22.2 x 14.8mm respectively). Consequently, the angle of view of a lens is 1.5x or 1.6x smaller when it is used on a camera with an APS-C sensor than when the lens is fitted to a full-frame camera. For example, a 50mm focal length delivers an angle of view of 47° on a full-frame sensor, but this reduces to 32° on an APS-C-sized sensor with a 1.5x crop factor. The practical effect of this "cropping" is that lenses fitted to an APS-C camera appear to have a longer focal length. In terms of exposure this has ramifications when factors such as depth of field are considered (see page 39).

35MM EQUIVALENT

Manufacturers use sensors in a wide variety of shapes and sizes. This makes the task of describing a lens' properties—specifically the angle of view—complicated. For this reason, many manufacturers refer not to the true focal length of a lens, but its 35mm equivalent.

Lens Types

There are three basic classes of lens in common use: wide-angle, standard, and telephoto. Which are the most useful will depend on your personal style of photography.

Wide-angle lenses capture an angle of view ranging from 180° (a "fisheye" lens) to approximately 62° (a 35mm focal length in full-frame terms). The most striking characteristic of wide-angle lenses is the exaggeration of the spatial relationships of elements in a scene. Elements of a scene that aren't close to the lens will appear far smaller and further from the camera than they do to the human eye. Landscape and architectural photographers make frequent use of wide-angle lenses to capture wide-open vistas or interiors.

A technical description of a "standard" (or normal) lens is that it has a focal length with the same measurement as the diagonal size of a camera's sensor. This means that (slightly ironically) there is no "standard" focal length that defines a standard lens, as many different sensor sizes are currently being used. On full-frame cameras, 50mm has long been considered the standard focal length (although, strictly speaking, 43mm is closer to the diagonal measurement of a full-frame sensor), while 28–35mm focal lengths are considered standard on APS-C formats, depending on the crop factor. Micro Four Thirds has a 25mm focal length as its standard, as it has a crop factor of 2x. Standard lenses are popular because the images they produce have a naturalistic look. For this reason they are frequently used for documentary projects.

The third lens type—telephoto lenses—can broadly be said to be any lens with a focal length longer than standard. Telephoto lenses magnify the image projected onto the sensor, increasing the size of the subject in the image space. Portrait photographers often use mild telephoto focal lengths in the region of 85mm, while sports and wildlife photographers will work with much longer telephoto focal lengths (300–400mm is common).

Right: From left we have Nikon F-mount 24mm, Canon EOS 50mm, and Sony E-mount 90mm lenses, which fall into the basic classes of wide-angle, standard, and telephoto lenses respectively (when fitted to a full-frame camera). Focal length is measured from the optical center of a lens, which isn't necessarily the front lens element, so one quirk of lens design is that focal length can't always be determined by the physical dimensions of a lens (hence the 24mm lens being significantly larger, physically, than the 50mm lens).

© Nikon, Canon, and Sony

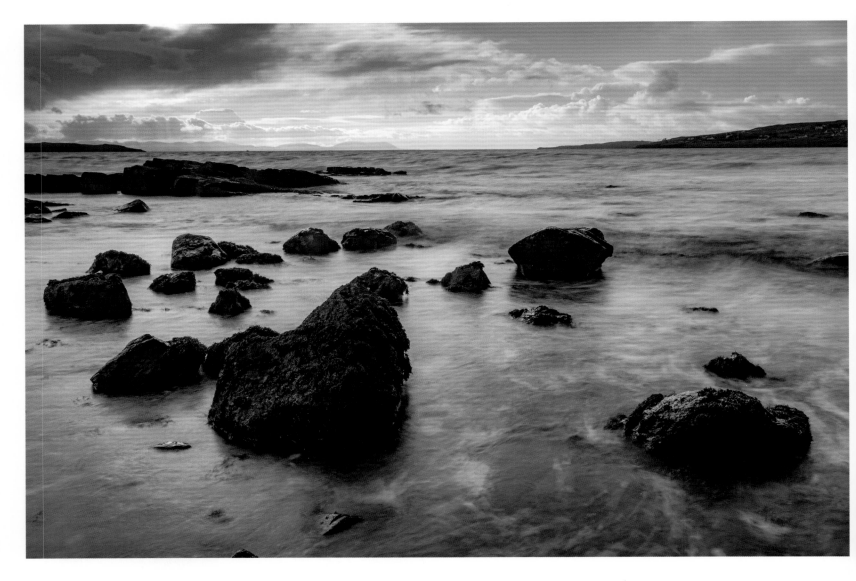

Above: Using a wide-angle lens often requires greater care with exposure than a telephoto lens; there is an increased chance of tonal variation across an image when shooting with a wide-angle lens due to its greater angle of view. This is particularly true when shooting a landscape, such as this coastal scene. In this instance, a 3-stop ND graduate filter was used to hold back the exposure of the sky so that it matched the darker bottom half of the scene.

Focal length: 30mm lens

Aperture: f/22

Shutter speed: 1.6 sec. (with 3-stop ND graduate filter)

ISO: 100

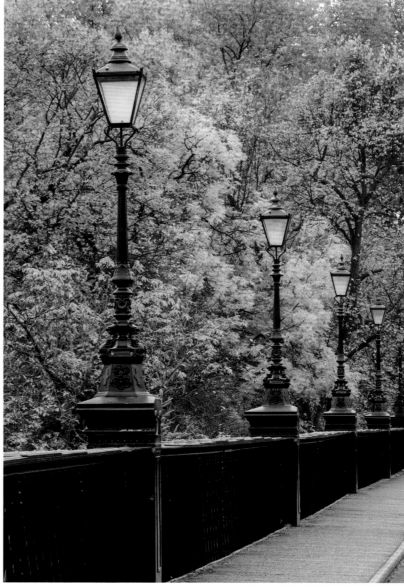

Above: The appeal of a standard lens is its unfussy visual qualities; perspective is naturalistic and similar to how we view the world. This makes it ideal when you don't want a dramatic visual style to overpower your subject, which is a problem that can occur with both wide-angle and telephoto lenses.

Focal length: 45mm

Aperture: f/4.5

Shutter speed: 1/320 sec.

ISO: 200

Above: A distinctive visual quirk of telephoto lenses is that spatial distances appear to reduce, visually pulling individual elements in the image closer together. The restricted angle of view of telephotos can also help to simplify exposure problems—in this case, framing tightly on the lamps and trees has excluded a bright, featureless sky.

Focal length: 200mm

Aperture: f/16

Shutter speed: 1/6 sec.

ISO: 100

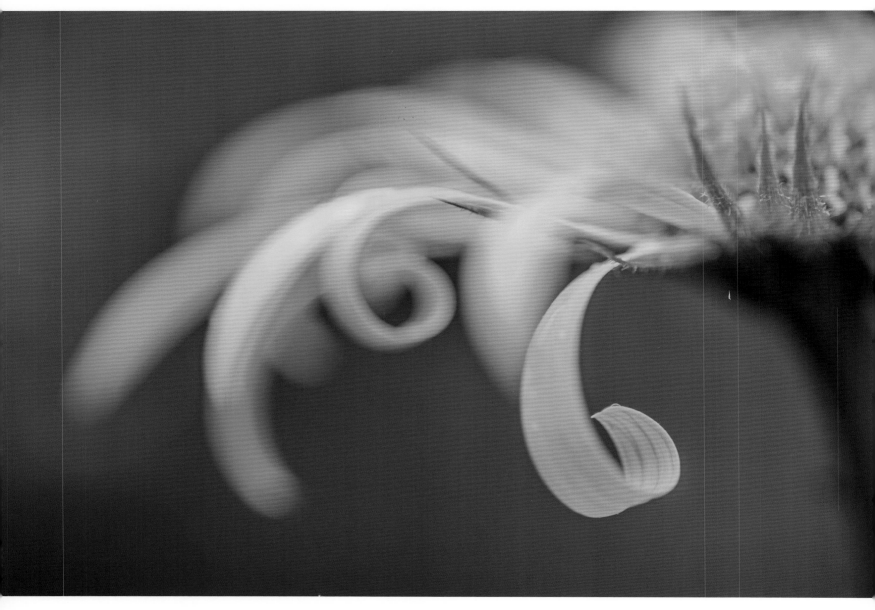

Aperture

Lenses come in all shapes and sizes, and vary in terms of build quality and price. A lens isn't just a way of framing and focusing on a scene, though; the aperture inside the lens is used as a way of controlling exposure (see page 38).

There is no standard range of apertures, and this is another way in which lenses vary. Typically, prime lenses offer a wide range of aperture choice, being faster than zooms, with larger maximum apertures. Some zooms compound this disadvantage by having variable maximum apertures, with one end of the zoom range (usually the longer focal length end) being slower than the other. Zoom lenses with fast, fixed maximum apertures tend to be larger, heavier, and more expensive than their slower, variable cousins.

Above: With a DSLR, the lens is held open at its maximum aperture setting until the moment of exposure. A lens with a large maximum aperture makes it far easier to focus manually, as the lens allows more light to reach the viewfinder, making it brighter.

Focal length: 100mm

Aperture: f/4.8

Shutter speed: 1/250 sec.

ISO: 200

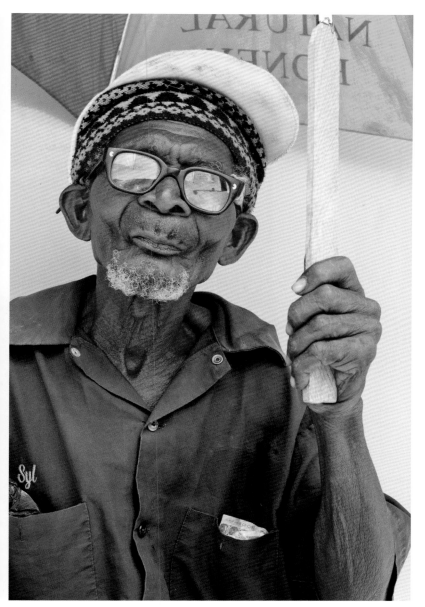

Size and expense aside, lenses with large maximum apertures have several advantages. In low light it's easier for both you and your camera's AF system to focus accurately. Creatively, they offer more opportunity for restricting depth of field to emphasize one particular area of a scene (see page 39). When shooting in low light, lenses with large maximum apertures make it less necessary to increase ISO in order to maintain a usable shutter speed.

Above Left: Prime lenses typically have larger maximum apertures than zooms. This is useful when shooting in low ambient light or when shutter speed is a higher priority than depth of field. Standard prime lenses are a useful addition to a street photographer's equipment.

Focal length: 50mm
Aperture: f/11
Shutter speed: 1/60 sec.
ISO: 400

Above: This image was shot using a compact camera with a 1/1.7" (7.44 x 5.58mm) sensor, with the lens set at 18mm. On a full-frame camera this would be a borderline ultra-wide-angle lens, but the small sensor on this camera means the angle of view is equivalent to 90mm.

Focal length: 18mm
Aperture: f/6.3
Shutter speed: 1/200 sec.
ISO: 80

Tripods

For some types of photography a tripod is unnecessary and would even be counter-productive. A good example is street photography, when a quick-witted and reactive approach to composition is required; the time spent setting up a tripod would mean potential shots could be easily missed. However, tripods are a necessity when a more considered approach to composition is needed and/or when light levels are such that it would be impossible to handhold a camera successfully. Typical users of a tripod include landscape and architectural photographers.

Choosing A Tripod

Most photographers tend to have a love/hate relationship with their tripod. There's a direct correlation between the weight of a tripod and its stability; a metal tripod is less likely to be knocked or blown over, but can be heavy to carry around for extended periods. Cheaper tripods made of plastic are lighter, and so easier to carry, but are also less stable. A good compromise between weight and stability comes from carbon-fiber tripods, but the downside is the cost—carbon-fibre tripods are often twice the price of a similar metal version.

The weight of your camera-lens combination is also a big factor in how stable a tripod is: the heavier the camera, the more stable and robust your tripod will need to be.

Above: Tripods differ in the number of leg sections they have, with the lowest being three. Tripods with fewer leg sections take less time to set up, but will be longer and bulkier when collapsed. A tripod with four leg sections, such as this Benro TAD28CB2, is well-suited to traveling, as it's more likely to fit into a small space such as a suitcase.
© Benro

Tripod Heads

Cameras are fitted to a tripod head, which can either be an integral part of the tripod or can be fitted separately if a tripod is bought "legs only." The latter option is recommended, as it means you can choose both the tripod and the head that best suit your needs.

There are three main types of tripod head: three-way, ball, and geared. A three-way head can be adjusted in one of three directions using a lever with a screw-locking mechanism. Ball heads pivot on a ball-and-socket joint that can be adjusted very finely before locking. Geared heads are similar to three-way heads, but the levers don't need to be locked; they can be adjusted by turning a geared knob that locks its position as soon as you stop turning.

Choosing a tripod head is arguably more of a personal choice than choosing the legs. If possible, it's worth experimenting with different types of tripod head to see which you prefer before making your final decision.

Right: Examples of tripod heads produced by the Italian tripod manufacturer Manfrotto. From left to right: three-way, ball, and geared heads.
© Manfrotto

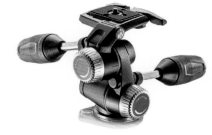
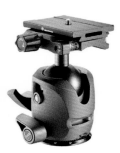
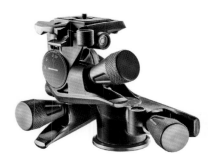

QUICK-RELEASE PLATE

A quick-release plate is a useful part of a tripod head. The plate screws onto the base of a camera so the camera can be quickly and securely locked to the tripod head. This saves time, as it means that your camera doesn't need to be screwed to the tripod every time you want to mount it.

Above: Shooting in the low light of a church interior with a long focal length lens would have resulted in unusable shots without a tripod. Even with a tripod I had to be careful not to move during the exposure and knock either the camera or tripod.

Focal length: 200mm

Aperture: f/11

Shutter speed: 3 sec.

ISO: 100

Light Meters

All modern digital cameras have built-in exposure meters, so a separate handheld light meter may seem like an unnecessary extravagance. However, they are still very useful, even in the digital world.

Camera exposure meters measure the amount of light reflected by a scene, which is known as making a "reflected" reading. Handheld meters measure the amount of light falling onto a scene—a technique known as making an incident reading (although most handheld light meters can be configured to make reflected readings too). The difference between a reflected and incident reading is subtle, but important, and will be expanded on in chapter three.

Used correctly, a handheld exposure meter has the potential to be far more accurate than the meter inside a camera. Handheld exposure meters are often able to measure flash exposures as well, which is important when using non-TTL flash systems or TTL flashes set to manual.

The most important part of a handheld light meter is a translucent white hemispherical dome known as the integrating sphere (or lumisphere). The integrating sphere covers the metering sensor when an incident light reading is made. This helps the metering sensor "see" how light would fall across your subject and so suggest the appropriate exposure settings. See page 83 to see how to take an exposure reading with a handheld light meter.

Above: The "Luxi for All" lumisphere clips over a smartphone's camera.

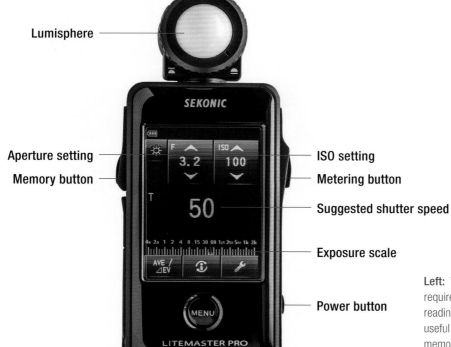

Lumisphere

Aperture setting — F ☀ 3.2

Memory button

ISO setting — 100

Metering button

T 50 — Suggested shutter speed

Exposure scale

AVE / △EV

Power button

SEKONIC

MENU

LITEMASTER PRO L-478D

Left: This light meter is set to display the shutter speed required for the selected aperture and ISO values; the reading is taken by holding in the metering button. One useful feature to have on a handheld light meter is a memory button. This lets you store several meter readings so you can compare the range of exposure values in a scene and so calculate its contrast.

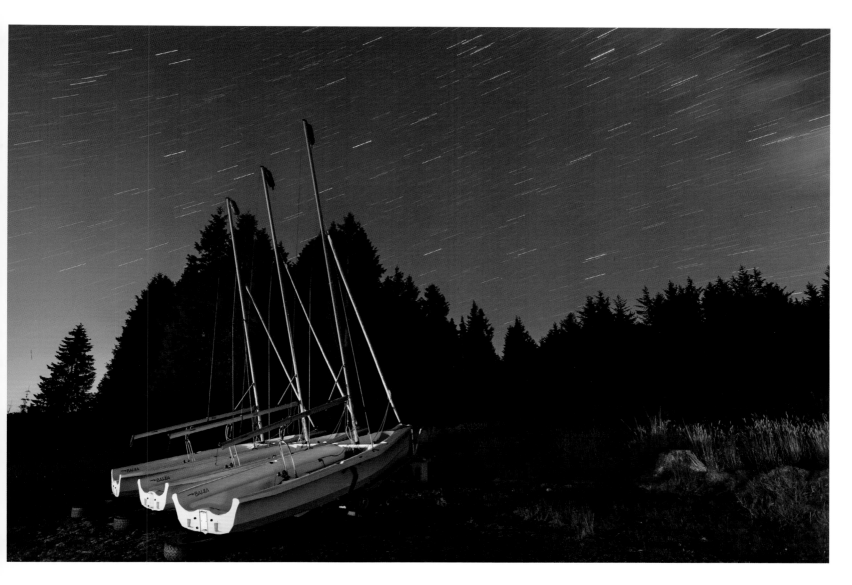

Above: One of the hardest exposure tasks is metering for a scene that requires a shutter speed greater than 30 seconds, as camera meters typically don't allow you to calculate exposure times longer than this. Handheld meters come into their own in this situation, as you can usually meter and calculate exposures that last several minutes. For this shot I used a handheld meter, then painted with light using a flashlight during an exposure that lasted almost 10 minutes.

Focal length: 20mm

Aperture: f/8

Shutter speed: 560 sec.

ISO: 800

Chapter 2

Exposure Basics

Exposure is the technique of allowing just the right amount of light to fall onto a digital sensor to produce a useful image. Written down it sounds simple, but it's a complex subject, with much to learn. Fortunately, it isn't so complicated that it's unlearnable; progress can be made quickly once a few key concepts have been grasped.

There are three main strands that need to be woven together in order to master exposure. Arguably, the most important strand is an understanding of light and its many qualities. The next strand is more technical: learning how a camera—or, more accurately, the digital sensor inside the camera—uses light to create an image. This also includes recognizing the limitations of digital sensors that can result in less-than-satisfactory images. The final strand requires knowledge of the various controls on a camera that are used to alter exposure. These three strands are all explored in this chapter.

Right: Exposure requires you to solve a series of small puzzles: what exposure mode should you use, is the exposure correct (and if not how should it be adjusted), and much more. Even a seemingly simple shot, such as this, required some thought about exposure. With practice, solving these puzzles becomes largely a matter of intuition.

Focal length: 18mm lens

Aperture: f/13

Shutter speed: 1/250 sec.

ISO: 200

Light

Without light there can be no photography. Therefore, as a photographer, light—no matter how little you have to work with—is something that needs to be understood and appreciated. Light has a number of different qualities. The easiest of these qualities to understand is intensity. The intensity or brightness of the light illuminating a scene affects the exposure settings required to make a successful image. How exposure is affected is covered later in this chapter. However, light has other qualities that have a more subtle effect on exposure, and these effects also need to be appreciated and acted upon if necessary.

Lighting Direction

When a photographer describes "lighting direction," this refers to the angle of the light source relative to the camera. There are four basic directions that light can fall relative to a camera: from behind the camera (frontal lighting), from the side (side lighting), from above (top lighting), or toward the camera (backlighting).

Of these four, frontal lighting is considered to be the least pleasing esthetically. As light is evenly spread across the side of the subject facing the camera, any shadows cast by the subject are behind it, out of sight of the camera. However, shadows help to define the shape of a subject, and convey three-dimensions in a two-dimensional image. Consequently, frontal lighting generally makes for dull and flat photos.

On-camera flash is a frontal light source and—as will be seen in chapter 7—there's a lot to be said for using flash away from the camera to create more interesting lighting effects. The one saving grace of frontal lighting is that exposure is relatively easy to get right, as there are few shadows to cause any problems with contrast.

Side lighting illuminates a scene approximately 35–100° to the camera (from either the right or the left). Side lighting is generally preferable to frontal lighting as the shape and texture of a subject is more readily revealed. Shadows are cast on the opposite side of the subject to the light source, which helps to create a sense that a subject is three-dimensional.

Side lighting can also be more dramatic, particularly when contrast is high, although contrast can also be problematic. When the light that illuminates your subject is hard, contrast is high, and this often makes it difficult to capture the full tonal range of a scene unless the light is modified somehow.

Contrast is lowered when the light is made softer or when either one or more fill-lights or reflectors are used to add light into the shadow areas. Another problem with side lighting (and backlighting) is that the risk of flare is increased.

Top lighting is a variation of side lighting; the difference is that light hits the subject from above. However, top lighting is less esthetically pleasing than side lighting. When shooting portraits, for example, shadows are cast below facial features such as the nose and chin—this is less-than-flattering and best avoided.

A scene is backlit when the light source is in front of the camera, often within the image space itself. Backlighting produces extremely high contrast that requires some thought to deal with photographically. The simplest solution is to expose for the light sources so that the main subject of the image is in silhouette (see pages 104–105). Another solution is to reduce the contrast in a similar way to side lighting, by using fill-lights or reflectors.

LENS FLARE

Lens flare is seen as streaks and colored shapes and/or a reduction of contrast in an image. It's caused when the light from a point light source is reflected and bounced around the individual glass elements that make up a lens. The light source doesn't need to be within the image space; flare can occur when a point light source is just outside the image space, particularly when a lens has a bulbous front element. Generally, keeping the front lens element clean will reduce the risk of flare, and using a lens hood will prevent flare caused by a light source outside the image space. If a lens hood can't be fitted to a lens, shading the lens so that the front element is in shadow will work—the key is not to include the shade in the final shot.

Soft & Hard Light

Light can also be said to be "hard" or "soft." Hard light is seen when the illumination source—whether artificial or natural—is small relative to the subject being lit. Hard light results in high contrast, with sharply defined borders between light and shade. Very small light sources are referred to as "point light sources." This type of light also produces very intense specular highlights on glossy surfaces. The texture of a subject, defined by the shadows and highlights cast by a hard light source, is usually highly pronounced.

When a light source is large relative to the subject, the light is said to be soft. Soft light sources produce low-contrast illumination. Shadows and highlights—if visible at all—are diffuse and soft-edged. Soft light is seen on overcast days when the sun is behind cloud,

Above: Frontal lighting is ideal when shooting flat subjects, such as a painting, when an even light is required across the subject. However, it tends to flatten the appearance of three-dimensional subjects due to the lack of shadows that help define shape.

Focal length: 50mm

Aperture: f/2.8

Shutter speed: 1/80 sec.

ISO: 450

Above: Composing so that the rising or setting sun is behind your subject is a simple way to create backlighting. Hide the sun's disk behind your subject to avoid flare.

Focal length: 20mm

Aperture: f/16

Shutter speed: 4 sec. (with 6-stop ND filter)

ISO: 100

when a subject is in shadow, or when a point light source has been modified through the use of a diffuser or reflector. Due to the reduction in the difference between the tonal values of the shadows and highlights, texture is less pronounced when shooting with a soft light source.

SPECULAR HIGHLIGHTS
A specular highlight is a small, sharp reflection of a point light source seen on glossy subjects. It's usually desirable to retain as much tonal detail in an image as possible, but specular highlights are an exception—if you attempt to retain detail in a specular highlight, the non-highlight areas of the image are certain to be grossly underexposed.

Above: The sun on a cloudless—or near cloudless—day produces light that's hard. It's only softened by cloud or when it's close to the horizon on a hazy day.

Focal length: 35mm

Aperture: f/14

Shutter speed: 1/40 sec.

ISO: 100

Above: Side lighting helps to define the form of a subject. This is particularly important when shooting architectural subjects; the side lighting on this cathedral helps to convey that this is a solid, three-dimensional structure. As there is no cloud, the light is hard on the towers of the cathedral.

Focal length: 24mm

Aperture: f/14

Shutter speed: 5 sec.

ISO: 100

Contrast

Photographically, contrast has many different meanings. In essence it describes a "difference," whether that's the textural qualities or colors in a scene. In terms of exposure, contrast defines the difference in brightness between the darkest and lightest areas of a scene (it can be used in a similar way to describe an image viewed either on screen or as a print).

When the difference in brightness between the lightest and darkest areas of a scene is pronounced, the scene is said to be high contrast. This occurs when a scene is illuminated by a hard light source or when a scene is side- or backlit. High-contrast scenes are generally the hardest to expose successfully, as the wide tonal range can often exceed a camera's dynamic range (see pages 56–57). Without modifying the light—with a diffuser, reflector, or additional lighting—the exposure often needs to be biased to record detail in either the shadows or highlights, but not both.

If the shadow and highlight brightness levels are close together, contrast is low. It's generally possible to capture an acceptable tonal range when shooting low-contrast scenes; low-contrast scenes are less likely to exceed a camera's dynamic range. However, when a scene is very low contrast there is often a need to add contrast later in postproduction. This is because low-contrast images can look flat and lack impact.

Above: High-contrast images have deep shadows and bright highlights, with relatively few midtones (above left). Low-contrast images tend to be mainly midtone, with relatively bright shadows and dark highlights (above right).

TONAL RANGE

The tonal range of an image describes the range of brightness levels from the darkest through to the lightest. The tonal range of a high-contrast image will be wide and can stretch from black through to white. Low-contrast images have a much narrower tonal range. The tonal range of an image can be seen by looking at its histogram (see pages 89–91).

Tip

Contrast is chiefly defined by the quality of the light illuminating a subject. However, image contrast can be adjusted to a certain degree using an appropriate picture parameter (see pages 70–71), or during postproduction.

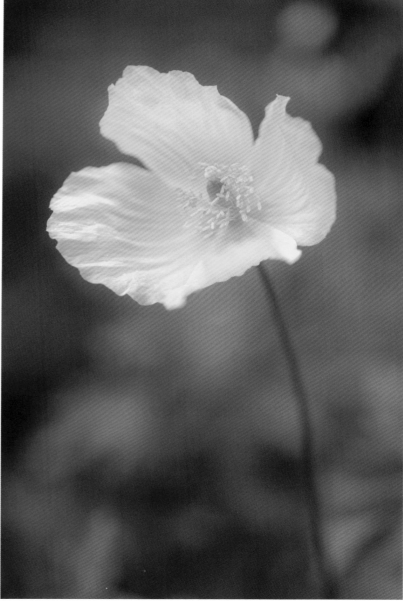

Above: Contrast is often very high when shooting backlit subjects. This often requires a compromise on how the image is exposed. In this example, the exposure was set to retain highlights, with the shadows dark and, in some areas, devoid of visible detail.

Focal length: 55mm

Aperture: f/4

Shutter speed: 1/30 sec.

ISO: 200

Above: The soft, often shadowless, light of an overcast day is ideal for shooting organic subjects, such as flowers. If the light isn't naturally soft, softness can be created by casting a shadow over the subject using a large reflector or even your own body.

Focal length: 100mm

Aperture: f/3.5

Shutter speed: 1/350 sec.

ISO: 400

Sensors

The sensor inside a camera has a profound influence on the exposure options open to you as you shoot. A sensor is made up of millions of cavities known as photosites, which capture light during an exposure that is then turned into an electronic signal. Typically, the larger the sensor, the larger the individual photosites.

Photosites & Light

Light that reaches a sensor during an exposure (or, more specifically, the packets of light energy known as photons reaching the sensor) can be thought of as units of information. The photosites begin to fill with photons when the camera's shutter-release button is pressed down to make an exposure. The number of photons collected during an exposure is counted and assigned a value between 0 and 255. A count of 0 means that a statistically insignificant number of photons were counted, resulting in no information—a black pixel. A count of 255 means that the photosite was filled to capacity, resulting in a surfeit of information— a white pixel.

The larger the individual photosites on a sensor, the greater the number of photons that can be gathered during an exposure. This means that a camera with larger photosites have more "information" that can be assessed and then processed to produce the final image. This generally means that cameras with larger sensors suffer less from problems such as low dynamic range (due to the lower likelihood of individual photosites filling during exposure) and image noise. A reasonable rule of thumb is that a camera with a small sensor will be less capable in scenes of high contrast or in low light.

RED, GREEN, AND BLUE
The most common sensor type uses a Bayer pattern filter in front of the sensor. To create a color pixel, an array of four photosites is used: one photosite is filtered red, two are filtered green, and one is filtered blue (this arrangement mimics the human eye's greater sensitivity to green wavelengths of light). The information from the four photosites is interpolated after shooting to produce a full-color pixel; this process is known as "demosaicing."

Left: The sensors in APS-C cameras, such as the Canon EOS 7D MkII, are a compromise in terms of ability and cost. Full-frame sensors cost more to manufacture for an arguably small improvement in factors such as dynamic range and noise.
© Canon

Clipping

If no photons are received by a photosite, the shadows are said to be "clipped." Likewise, if there are too many photons gathered and the photosite is filled to capacity, then the highlights are clipped.

Sensors are linear devices. The information they gather during an exposure is directly proportional to the amount of light that falls onto the sensor: when shadows or highlights clip there is no gradual roll-off in brightness to disguise the transition.

Visually, clipping is more noticeable when dealing with highlights; we expect shadows to be dark and lacking in a certain level of detail, but the human visual system does not clip highlights. Therefore, a hard transition to white in a photograph looks decidedly unnatural.

The risk of clipping increases in high-dynamic range scenes (see pages 56–57). This then involves a choice: expose for the highlights (and potentially lose detail in the shadows), or expose for the shadows (and clip the highlights). Generally, unless shadow detail is important, the former is the preferable option. Clipped highlights can sometimes be recovered during postproduction when shooting Raw, but clipped highlights in JPEG images are not recoverable.

Above Right: In playback, cameras can warn of highlight clipping (and less commonly shadow clipping). This warning is known as "blinkies" due to the fact that the clipped highlight pixels flash. Postproduction software, such as Adobe Lightroom, shown here, can usually be set to show problematic shadow and highlights areas. Here the clipped highlights are colored red.

Right: Careful composition can be used to reduce the risk of clipping. For this shot, the brightest sun-lit areas of the sky were hidden behind the foliage of the tree on the left.

Focal length: 30mm

Aperture: f/11

Shutter speed: 1/200 sec.

ISO: 100

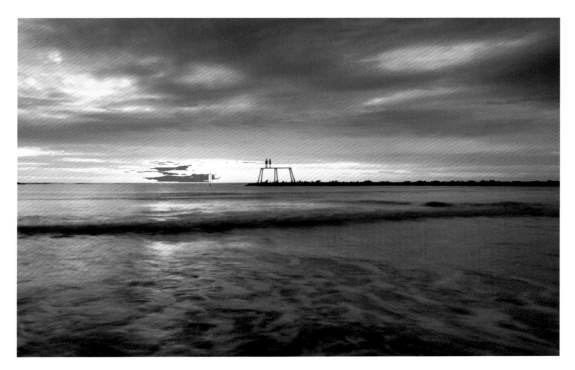

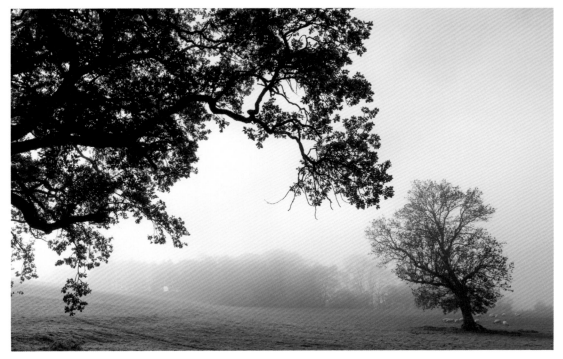

Exposure

The sensor inside a camera must receive the right amount of light in order to make a successful image. There are two controls on a camera that let you physically adjust how much light reaches the sensor: the aperture and the shutter speed. A third control specifies the amount of light required by the sensor to make the image: ISO. The combination of these three controls determines not only how well or not an image is exposed, but also the visual characteristics of the photograph.

Stops

One of the key concepts to grasp when learning to master exposure is the idea that the amount of light reaching the sensor can either be halved or doubled. This process is known as adjusting the exposure by a "stop."

When the amount of light reaching the sensor is halved, the exposure is said to have been reduced by 1 stop. This can be achieved by halving the size of the aperture, halving the duration of the shutter speed, or by halving the ISO value.

Conversely, when the light is doubled, the exposure is increased by 1 stop. This occurs when the aperture size is doubled, the duration of the shutter speed is doubled, or the ISO value is doubled.

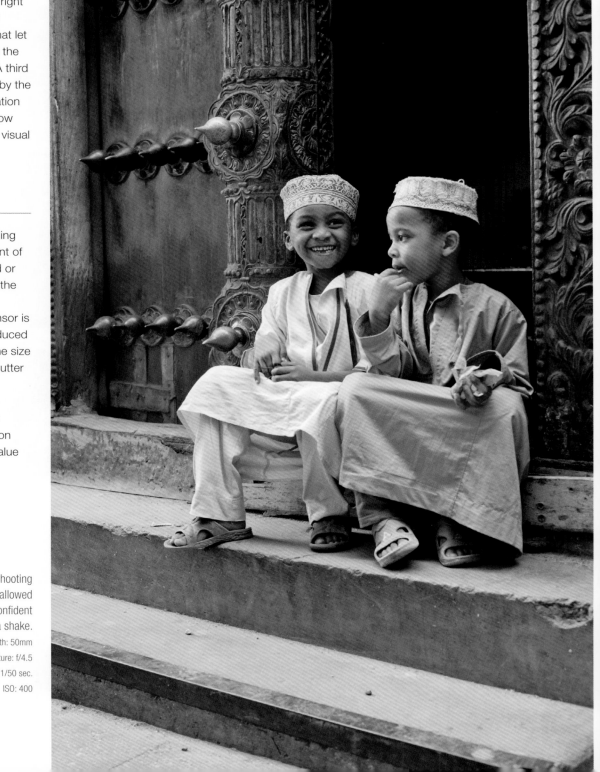

Right: Increasing the ISO was a necessity when shooting on the dark streets of Stone Town, Zanzibar. This allowed me to shoot using a shutter speed that I was confident wouldn't introduce camera shake.

Focal length: 50mm

Aperture: f/4.5

Shutter speed: 1/50 sec.

ISO: 400

Exposure Triangle

If you adjust one of the exposure controls, either one or both of the other two controls must also be altered in order to maintain the same level of exposure. This concept is easily grasped visually using a diagram known as the exposure triangle (see below). An understanding of the exposure triangle is important because an adjustment of the shutter speed has a different visual effect to adjusting either the aperture or ISO. Selecting the required combination of shutter speed, aperture, and ISO means deciding on the visual character of the final image.

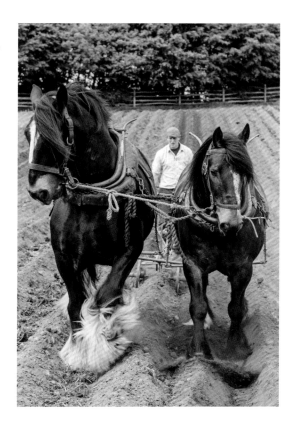

Left: Setting exposure means thinking about the three corners of the triangle and what compromises need to be made. For this shot, I wanted to use a reasonably fast shutter speed to "freeze" the movement of the horses. However, I didn't want to use too high an ISO. The compromise in this case was to use a relatively large aperture, which restricted the available depth of field.

Focal length: 50mm

Aperture: f/5

Shutter speed: 1/200 sec.

ISO: 100

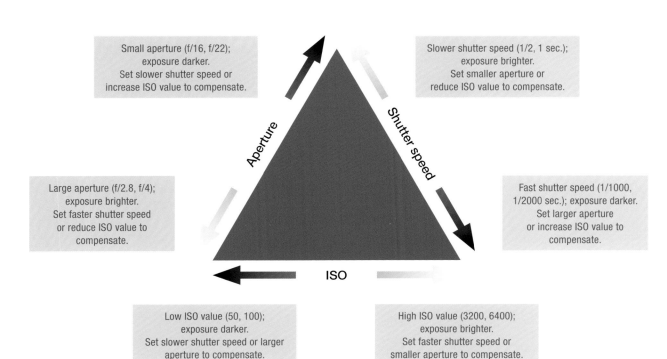

Small aperture (f/16, f/22); exposure darker. Set slower shutter speed or increase ISO value to compensate.

Slower shutter speed (1/2, 1 sec.); exposure brighter. Set smaller aperture or reduce ISO value to compensate.

Aperture

Shutter speed

Large aperture (f/2.8, f/4); exposure brighter. Set faster shutter speed or reduce ISO value to compensate.

Fast shutter speed (1/1000, 1/2000 sec.); exposure darker. Set larger aperture or increase ISO value to compensate.

ISO

Low ISO value (50, 100); exposure darker. Set slower shutter speed or larger aperture to compensate.

High ISO value (3200, 6400); exposure brighter. Set faster shutter speed or smaller aperture to compensate.

Aperture

The size of the aperture opening is measured in a series of discrete steps known as f-stops (shown as f/ followed by a suffix number). A fairly typical range of f-stops on a lens is f/2.8, f/4, f/5.6, f/8, f/11, f/16, and f/22. Slightly counterintuitively, f/2.8 is the maximum (or largest) aperture and f/22 is the minimum (or smallest). The reason for this seemingly illogical sequence is that an f-stop value describes the diameter of the aperture as a fraction of the focal length of the lens. So, for example, when the aperture is set to f/8 on a 50mm lens, the aperture would be 6.25mm in diameter (50/8=6.25); at f/11 the aperture diameter would be 4.54mm (50/11=4.54).

If you jump between f-stops from left to right in the sequence above, the amount of light that passes through the aperture and into the camera is halved (f/4 halves the amount of light passing through the aperture compared to f/2.8; f/5.6 halves the light compared to f/4; and so on, through to f/22). Conversely, read the sequence from right to left and the amount of light passing through the aperture doubles as you jump between f-stops. Each time you make a jump (whether from left to right or right to left) the difference is referred to as one "stop." Most cameras let you alter f-stop values in ½- or ⅓-stop increments, which would add more values into the sequence above; f/3.2 and f/3.5 slot in between f/2.8 and f/4 when ⅓-stop values are used, for example.

SETTING THE APERTURE

The aperture is set using one of two methods. It can either be set via an aperture ring on the lens itself (above left). Or, more commonly, it can be set electronically using a dial on the camera body (above right). When there's a choice, it's largely a matter of preference which one is used. The advantage to using the dial method is that when you swap lenses the aperture setting will stay the same (providing it's available on the new lens). This is not guaranteed if you swap lenses and the aperture has been set using the aperture rings.

LENS ADAPTORS

One of the benefits of mirrorless cameras is that they can use virtually any lens designed for an SLR (or rangefinder camera) via a lens adaptor. A lens adaptor effectively increases the depth of a mirrorless camera to match the depth of the camera that the lens was originally designed for.

There are several different types of lens adaptor. The simplest have no mechanism for adjusting the aperture on the lens, so only lenses with aperture rings are suitable. More sophisticated lens adaptors allow you to adjust the aperture via a ring on the adaptor, although you typically can't set an exact aperture value, only an approximate value between the lens' maximum and minimum settings.

The third—and most useful—adaptors offer a high degree of automation. This includes setting a precise aperture value and even allowing autofocus functionality. These adaptors are typically produced by camera manufacturers to ease the transition from their DSLR systems to their mirrorless cameras.

Depth Of Field

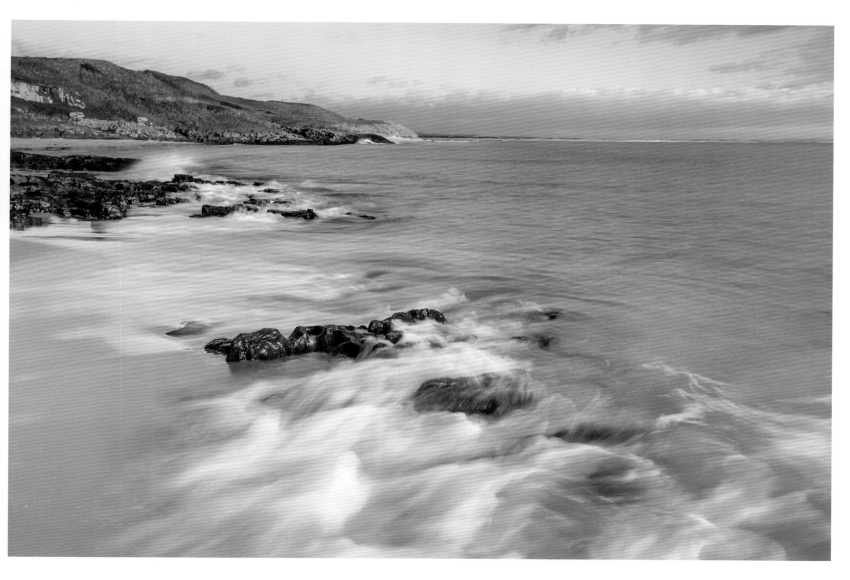

The sharpest area of an image is the plane of focus. This is a plane parallel to the camera at the focus distance set on the lens. On a simple lens the plane of focus is often the only part of the projected image that's actually sharp. Fortunately, the aperture in a lens also has an influence on image sharpness. The aperture creates a zone of sharpness known as "depth of field." The smaller the aperture used, the greater the extent of depth of field and acceptable image sharpness. Depth of field extends from the plane of focus both toward and away from the camera. However, depth of field doesn't extend equally away from the focus plane: it extends twice as far away from the focus plane than forward, toward the camera.

An important factor that influences the extent of depth of field is the focus distance. Depth of field at a given aperture decreases with focus distance.

Above: The more three-dimensional a scene, the more important the selected aperture becomes. If you want to achieve front-to-back sharpness then smaller apertures are generally necessary, even when shooting with a wide-angle lens.

Focal length: 32mm

Aperture: f/16

Shutter speed: 1/3 sec.

ISO: 100

This has particular ramifications when shooting macro subjects: it's often difficult to create adequate depth of field to ensure front-to-back sharpness, even when using a lens at its minimum aperture setting.

Visually, the focal length of a lens appears to alter depth of field too; the longer the focal length of a lens, the less apparent depth of field is available at a given aperture. This means it's easier to achieve front-to-back sharpness with a wide-angle lens than a telephoto lens.

Right: Limiting depth of field can help to simplify a composition. Here, the use of a large aperture has softened the hard reflections on the glass cabinet I was shooting through. In fact, by a happy accident they now look like beams of light illuminating the figure.

Focal length: 40mm

Aperture: f/4

Shutter speed: 1/10 sec.

ISO: 800

Sensor Size

The size of a camera's sensor affects the focal length required to achieve a particular angle of view. Cameras with sensors smaller than full frame require lenses with shorter focal lengths to achieve an equivalent angle of view. However, shorter focal length lenses appear to increase the available depth of field at a given aperture. As a result, some compact cameras—particularly at the wider end of the lens' zoom range—create an apparently infinite depth of field, even when set to maximum aperture. This is useful for landscape photography if front-to-back sharpness is desirable, but restricting depth of field for effect can become difficult (if not impossible) unless the longer end of the camera's focal length range is used. Choosing a particular camera therefore has ramifications for the types of images that can be shot when the aperture is varied.

Above: These images were shot from the same position and with the same aperture (f/2.8). The difference in depth of field is due to a change in focal length. The image above left was shot using a full-frame camera with a 200mm lens, while the image above right was shot using an APS-C camera with a 135mm lens (to match the angle of view).

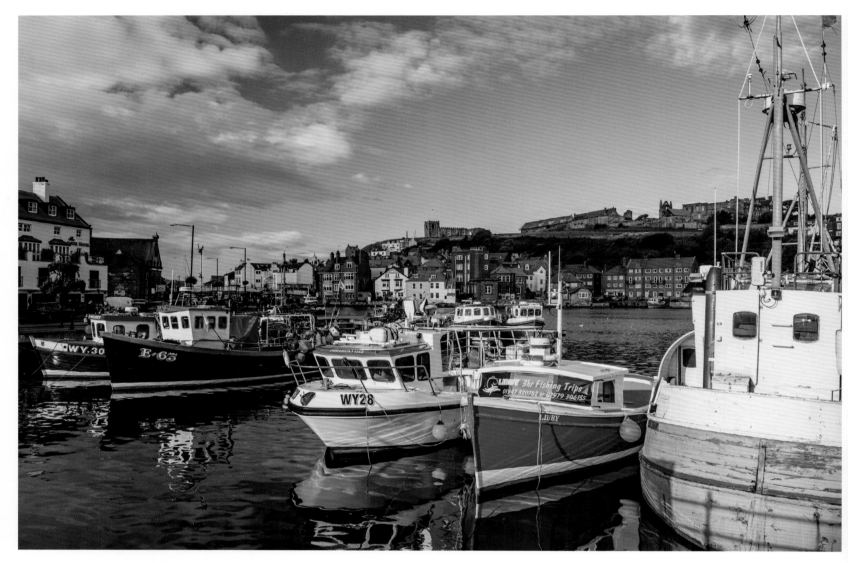

Depth Of Field Preview

When you look through an optical viewfinder, the aperture in the lens is held open at its maximum value, so you see depth of field at its minimum extent. In order to assess depth of field the camera's depth of field preview button must be pressed and held down. When you do this, the aperture is closed to the value selected either by you or your camera. It's only then that the true extent of depth of field can be seen.

Unfortunately, there's one drawback to using depth of field preview. As the aperture size is reduced (assuming you're not using maximum aperture) the viewfinder will go darker; the smaller the selected aperture, the darker the viewfinder will be. This can be problematic in low light or when using an aperture close to the lens' minimum, but if you let your eyes adjust it's surprising how much you depth of field you can see.

In many ways, Live View is a better option for judging depth of field. You may still need to hold the depth of field preview button to close the aperture down to see depth of field change,

Above: To achieve front-to-back sharpness in an image (without the use of a tilt-and-shift lens) generally means using one of the smaller apertures available. For a brightly lit scene, such as this harbor view, this still allows the use of a relatively fast shutter speed. The compromise when shooting in lower ambient light is a slower shutter speed, with a greater risk that moving objects (such as boats bobbing up and down) will be unsharp due to motion blur.

Focal length: 28mm

Aperture: f/14

Shutter speed: 1/50 sec. (with polarizing filter)

ISO: 100

but some cameras close the aperture automatically when viewing a Live View image, so using the depth of field preview button isn't necessary.

A side effect when shooting in low light is that the display may start to appear grainy when the aperture is closed down. This is because the camera amplifies the signal received from the sensor in order to maintain a constant brightness on the LCD screen. However, this drawback (if you ever encounter it) is more than offset by the fact that you can typically zoom into a Live View display to check that critical areas of a scene are sharp. This is something that is impossible to achieve with an optical viewfinder.

Right: The aperture is set at its maximum setting until the moment of exposure. This is partly so that you can see the brightest possible image in the viewfinder, and partly because it helps the camera's autofocus system. The more light that reaches the AF sensor, the faster and more accurate the focusing will be.

Focal length: 50mm

Aperture: f/1.8

Shutter speed: 1/160 sec.

ISO: 320

Shutter Speed

The range of aperture settings available is lens dependant, but the shutter speed range is determined by the camera. System cameras offer a greater range of shutter speed settings than compact or cellphone cameras; system cameras will typically allow you to shoot between 1/4000 sec. (sometimes even 1/8000 sec.) and 30 seconds. Most system cameras will also enable you to lock the shutter open for an indefinite period of time using "Bulb" mode.

As with the aperture, shutter speeds are varied in stops. Starting with the fastest setting (typically 1/4000 sec.) shutter speeds get longer and double the amount of light that's allowed to reach the sensor—1/2000 sec., 1/1000sec., 1/500sec., 1/250sec., and so on, down to 30 seconds.

Above: The shutter speed you use is entirely arbitrary if your subject is static. Here, the shutter speed could be set to any point in the available range and visually there would be little difference (although depth of field would alter as the aperture would need to change, or noise would vary in intensity if the ISO was adjusted). Shoot a moving subject, however, and the selected shutter speed will determine how that movement is rendered in the final image.

Focal length: 45mm

Aperture: f/9

Shutter speed: 1/40 sec.

ISO: 200

Movement

There are two broad approaches to capturing movement: movement is either frozen through the use of a fast shutter speed, or a degree of blurring is created through the use of a slower shutter speed (the slower the shutter speed, the greater the blurring effect).

Freezing Movement

There is no single shutter speed that will freeze movement, as both the size of the moving subject within the image space and the direction of its travel need to taken into account; a subject moving across the image space will require a faster shutter speed than one moving toward or away from the camera. See the grid on the following page for suggested shutter speeds needed to freeze the movement of commonly encountered subjects.

Ultra-fast movement, such as capturing droplets of water, may require shutter speeds that exceed the available range, even on high-end cameras. Ultra-fast movement therefore generally requires a different technique to freeze the movement (see page 145).

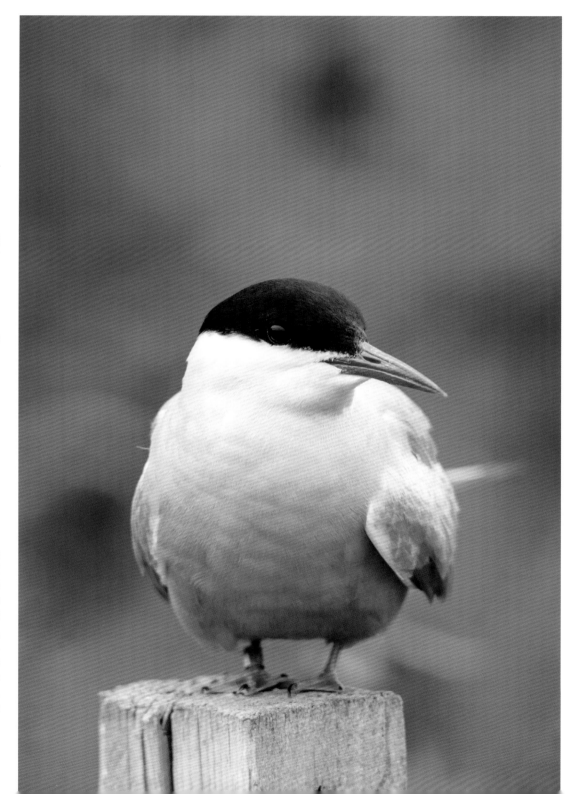

Right: Subjects that move quickly and unpredictably require the use of a fast shutter speed to avoid any blur caused by their movement. Even with a high ISO setting this often means using a large aperture that, on a telephoto lens particularly, restricts depth of field. With human or animal subjects it's typically the eyes that should be sharpest, which is where I focused on this Arctic Tern.

Focal length: 200mm
Aperture: f/4
Shutter speed: 1/1000 sec.
ISO: 400

SUBJECT	WHEN FILLING FRAME	WHEN HALF-FILLING FRAME
Person walking slowly	1/125 sec.	1/60 sec.
Person walking slowly	1/250 sec.	1/125 sec.
Person running	1/500 sec.	1/250 sec.
Person cycling	1/500 sec.	1/250 sec.
Horse galloping	1/1000 sec.	1/500 sec.
Car traveling 20–40mph/32–64kph	1/500 sec.	1/250 sec.
Car traveling 50–70mph/80–112kph	1/1000 sec.	1/500 sec.
Train	1/2000 sec.	1/1000 sec.
Fast jet	1/4000 sec.	1/2000 sec.

Above: The shutter speed you or your camera chooses will have several effects, the most important of which is how movement is recorded in the final image. A fast shutter speed will help "freeze" movement and show detail that would otherwise not be seen by the naked eye.

Focal length: 200mm

Aperture: f/4.5

Shutter speed: 1/2500 sec.

ISO: 100

Blurring Movement

In many ways, blurring movement is an easier option than freezing it. Using a longer shutter speed to blur movement requires the use of a low ISO setting or relatively small aperture (or a mixture of the two). ND filters (see pages 132–133) are useful If the light level is too high to allow the required settings for either ISO or aperture.

The main decision to be made when choosing to record movement blur is the degree of blur. The longer the shutter speed used, the greater the amount of blur, and the more abstract the final image—use too long a shutter speed and your subject may not even register in the final image. See the grid below for a range of different subjects and suggested shutter speeds to produce different levels of blur.

SUBJECT	SHUTTER SPEED
Waterfall	1/4 sec.
Fireworks—slight trail	1 sec.
Waves—retaining detail	1 sec.
Wind-blown foliage—slight blurring	2 sec.
Moving clouds—slight blur	8 sec.
Waves—detail lost	15 sec.
Fireworks—pronounced trail	15 sec.
Wind-blown foliage—heavy blurring	30 sec.
Traffic trails	30–60 sec.
Waves—mist-like quality	1–2 min.
Moving clouds—heavily blurred	2–3 min.
Star trails	10+ min.

Above: If you shoot at night, the light levels are low, even on brightly lit city streets, which typically means using long shutter speeds. When photographing moving traffic, only the trails of the headlights or tail lights will be recorded—the shape and character of individual cars is lost.

Focal length: 100mm

Aperture: f/18

Shutter speed: 8 sec.

ISO: 100

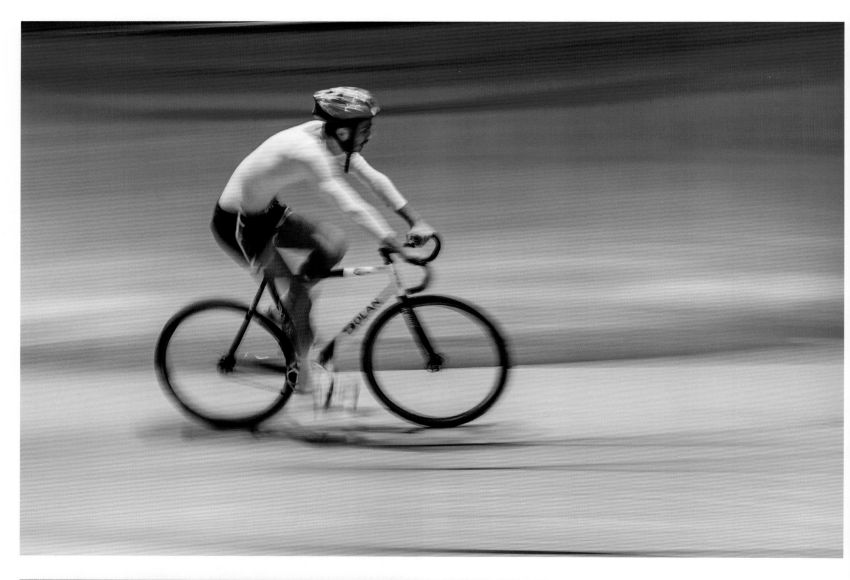

PANNING

There are times when a sharp moving subject is required, but low ambient light levels preclude the use of an appropriately fast shutter speed. One solution is to use a technique known as panning, where the camera is moved in an arc to follow the subject (when the subject is moving at right angles to the camera). During the camera movement the shutter is fired and released approximately halfway through the arc. This takes some practice, but the result is that the subject should be relatively sharp, while the background behind is blurred (caused by the movement of the camera). Different subjects and shutter speeds will produce different results, but a shutter speed between 1/125 sec. (for faster moving subjects, such as cars) and 1/8 sec. generally works well.

Above: It's a subtle irony of photography that a sense of speed is best conveyed by blur. Blur is generally achieved through the use of a relatively slow shutter speed—this image was shot at 1/8 sec. To keep the cyclist relatively sharp, I panned the camera to follow his movement, firing the shutter when he was at his closest to the camera and at the required point in the frame.

Focal length: 70mm

Aperture: f/8

Shutter speed: 1/8 sec.

ISO: 100

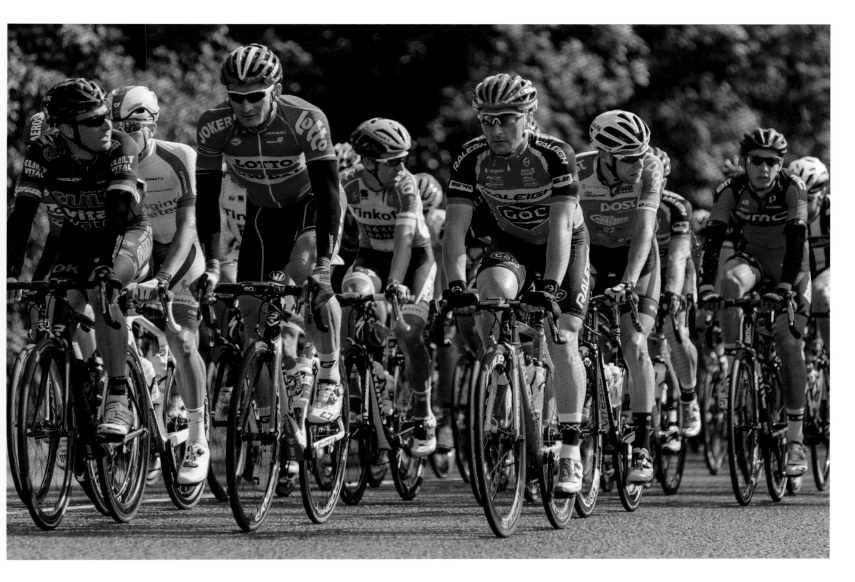

Above: A similar subject to that opposite, but a completely different approach to shooting. For this shot, the shutter speed was increased to freeze the movement of the bikes. The cyclists were traveling at approximately 20 miles per hour (32kph). However, this is difficult to appreciate due to the static nature of the shot.

Focal length: 200mm

Aperture: f/4

Shutter speed: 1/4000 sec.

ISO: 800

Camera Shake

Camera shake is unsharpness in an image that is caused when the camera accidentally moves during an exposure. Camera shake has a different visual quality to unsharpness caused by a focusing error; there's an obvious directionality to camera shake that precisely follows the movement of the camera during the exposure.

The risk of camera shake is greatest when you are handholding your camera and a relatively long shutter speed is required. The risk increases when using longer focal length lenses, as the effects of any camera movement are magnified more when using telephoto lenses than wide-angle lenses. Image stabilization systems can help to mitigate the risks of camera shake, but even with it activated, camera shake will still become a problem once the shutter speed is sufficiently long.

The precise shutter speed that causes camera shake when using a particular lens varies from person to person, as some people are naturally steadier than others. It pays to experiment with the lenses you own to see where your limits are. This can be done by shooting a series of images with the lenses, gradually reducing the shutter speed as you do. However, even this will only be a guide: shoot outside in a brisk wind or on an unstable surface and you'll find that the risk of camera shake increases, requiring a faster shutter speed than expected.

Left When you use a slow shutter speed to shoot a moving object, detail will be lost due to blur. The slower the shutter speed, the greater the level of blur (and the greater the risk of camera shake).

Focal length: 70mm

Aperture: f/16

Shutter speed: 6 sec.

ISO: 100

A reasonable guide to avoiding camera shake (assuming image stabilization isn't available) is to set the shutter speed to a value greater than the selected lens' full-frame focal length equivalent. As an example, when using a 50mm focal length equivalent the shutter speed should be set to 1/50 sec. or faster, with a 200mm focal length the shutter speed should be 1/200 sec. or faster, and so on.

However, high-resolution sensors (those with 24 megapixels or higher) are less forgiving of camera shake, so a shutter speed that is at least 2x the focal length is more appropriate (1/100 sec. or faster for a 50mm lens, 1/400 sec. or faster for a 200mm lens, and so on).

Right & Below: Camera shake can be distinguished visually from a focusing error, as blur caused by camera shake has a definite directionality.

Focal length: 200mm
Aperture: f/2.8
Shutter speed: 1/40 sec.
ISO: 800

ISO

The size of the aperture in the lens and the shutter speed you select both affect how much light is allowed to reach the camera's sensor. However, the amount of light that's required to make a successful image is determined by the ISO setting you choose.

ISO Basics

Cameras have a range of ISO settings, the lowest of which is known as its "base" ISO. At its base ISO the sensor is at its least sensitive to light, but as the ISO is increased, the sensor requires less and less light to make an image. This increase in sensitivity is achieved through electronic amplification of the signal created by the photons hitting the sensor.

Raising the ISO allows you to use a faster shutter speed or smaller aperture than would otherwise be possible when using the base ISO. The drawback is that noise—a sampling error caused by the signal amplification process—increases as ISO is raised. Other drawbacks of using higher ISO settings are that both color fidelity and image dynamic range are reduced. There is also less scope for postproduction adjustment with a high ISO image than one shot at base ISO, so the exposure needs to be far more accurate when shooting with a high ISO setting. These

Right: Base ISO should be used to maximize image quality. The drawback when shooting in low light is that either a long shutter speed or large aperture is required—or both if the light levels are sufficiently low. Using base ISO therefore requires compromise: in this instance, the compromises were the use of a long shutter speed and a tripod to avoid camera shake.

Focal length: 200mm
Aperture: f/4.5
Shutter speed: 3 sec.
ISO: 100

drawbacks are often acceptable if factors such as an increased risk of camera shake marring an image will be more problematic. However, to maximize image quality and to allow for greater postproduction adjustment it's preferable to use the camera's base ISO whenever possible.

ISO Range

The base ISO varies between camera models: it can be as low as ISO 64 or as high as ISO 200, with ISO 100 being the most common value. There's theoretically no upper limit to the highest ISO possible, but the highest ISO settings are generally higher on system cameras (particularly those with full-frame sensors) than compact cameras. At the time of writing, the current high ISO champion is the Sony A7s II, which has a maximum ISO of 409,600.

A respectable camera ISO range is 100, 200, 400, 800, 1600, 3200, and 6400 (with ½ or ⅓-stop values often available that fit in between these values). Reading from left to right, each ISO value indicates that the sensitivity of the sensor has been increased by 1 stop. In practical terms this means that with each doubling of the ISO value, half as much light is required to make a correctly exposed image. Read the values from right to left and each halving of the ISO value means twice as much light is required to make a correctly exposed image.

Increasing the ISO on a camera is roughly equivalent to underexposing by the same number of stops and then normalizing the exposure in postproduction; in both cases there will be an increase in image noise compared to shooting at base ISO. However, most cameras are ISO-variant. This means there is less noise penalty when using a higher ISO than normalizing an underexposed image. There are currently very few cameras that feature ISO-invariant sensors; a type of sensor where there is little or no difference between high ISO noise and noise seen when an underexposed image is normalized (although shot noise will prove to be a factor with the latter). If in doubt, it is better to use a higher ISO setting, rather than relying on postproduction software to rescue an underexposed shot.

Above: A close-up of the image opposite, shot at both ISO 100 (above left) and ISO 12,800 (above right) shows the difference that altering the ISO makes. Noise has smothered fine detail in the image shot at ISO 12,800.

Noise

All digital images, whether captured by a camera or a scanner, suffer from noise to one degree or another. Noise is seen as non-subject-related pixel-level fluctuations across an image and is most often visible in areas of continuous tone such as sky (subjects that have a discernible texture, such as rock, tend to naturally hide the visual effects of noise). There are two basic types of noise commonly seen—shot and electronic. A third type—thermal noise—is only seen under specific conditions. Electronic noise can be visually divided into two types: luminance and chroma noise.

Shot Noise

The number of photons falling into a photosite over a set of period of time is essentially random, so if you repeated the photon-gathering-and-counting process over and over you would see a subtly different result each time. This randomness produces a form of image noise known as shot noise. In a "normal" exposure, shot noise is not an issue—the more photons collected by a sensor, the less significant variability becomes.

The effects of shot noise become more apparent, however, if you underexpose an image and then correct the exposure in postproduction. This is because the variability—as a proportion of photons collected—is greater. Shadows suffer more than highlights for similar reasons—fewer photons of light are gathered from the shadow areas of a scene than the highlights. Larger sensors, with larger photosites are capable of collecting more photons over a set period of time, so suffer less from shot noise than smaller sensors.

Electronic Noise

The effect of electronic noise varies according to the sensor in the camera, and is typically seen more prominently as ISO is increased.

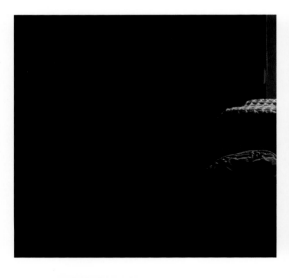

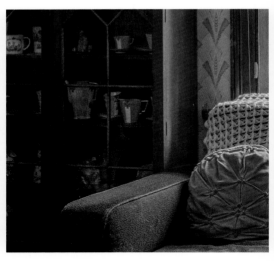

Above: Underexposing and then compensating in postproduction can produce very visible noise in an image. The level of noise will be determined by the degree of compensation and the dynamic range of the sensor.

Focal length: 28mm

Aperture: f/7.1

Shutter speed: 1/13 sec.

ISO: 200

SIGNAL-TO-NOISE RATIO

A signal-to-noise ratio is a comparison of the amount of useful information gathered by an electronic system to the level of background noise. When visible, shot noise indicates a low signal-to-noise ratio: there is more image noise compared to usable image detail. Ideally, the exposure should be set so that the signal-to-noise ratio is as high as possible. ETTR is one technique that can be used to achieve this (see pages 106–107).

Random noise is seen as fluctuations in both pixel brightness and color in an image—luminance and chroma noise respectively. Luminance noise is the least objectionable visually as it resembles film grain in character; the higher the level of luminance noise, the more "gritty" an image looks.

Chroma noise is seen as random color blotches across an image. Visually this is less appealing than luminance noise and also harder to remove successfully during postproduction. Fortunately, modern sensors are generally very good at suppressing both luminance and chroma noise until the highest ISO settings are selected.

Banding noise is more regular in pattern, and is generated by the camera as image data is read from the sensor. This type of noise is seen less frequently, as sensor technology has improved. When it is seen, it is typically most prominent when a high ISO has been used, or when over-enthusiastic brightening is applied to an image in postproduction.

CHANNELS

Pixels are a mix of red, green, and blue, with the values for each color stored in a separate channel. Typically, the blue channel is far noisier than either the red or green channels.

Thermal Noise

Camera sensors generate heat when they're activated. During a long exposure—typically lasting 1 minute or more—this heat adds noise, known as thermal noise, to an image. The amount of thermal noise in an image increases the longer the exposure continues. However, camera sensors differ in their susceptibility to thermal noise, so the only sure way to determine the characteristics of your camera's sensor is to make some test exposures. Thermal noise is seen as bright colored pixels randomly scattered across an image (these are commonly referred to as "hot pixels").

Unlike high ISO noise, thermal noise is difficult to remove in postproduction. However, most cameras feature a long exposure noise reduction function that is applied to images when exposures longer than 1 second are used.

The technique to remove thermal noise is known as dark frame subtraction. After the image exposure, the camera shoots a second exposure of exactly the same duration, this time with the shutter closed. Theoretically, this second exposure should be completely black. If it is not, then thermal noise is present; the camera can determine where it is within the frame and subtract it from the image exposure.

The downside to this technique is that it effectively doubles the exposure time. A careful watch therefore needs to kept on your camera's battery level when shooting with long exposure noise reduction activated—there's nothing more frustrating than a battery dying halfway through the noise-reduction process.

Above & Right: When an image is reproduced at a relatively small size, thermal noise may not be noticeable. However, at 100% magnification (right), thermal noise is problematic and will mar an image. This shot was eventually converted to black and white to help mask the noise.

Focal length: 90mm

Aperture: f/16

Shutter speed: 480 sec. (with 10-stop ND filter)

ISO: 100

Dynamic Range

One of the hardest photographic lessons to learn is why a camera is often unable to record a scene exactly as perceived. Either the shadows in a photograph are dense and lacking in detail, or the highlights have burnt out and can't be recovered. It's only under certain conditions that the digital sensor inside the camera is able to capture a sufficient tonal range similar to that perceived by the human eye.

The phrase "dynamic range" has two uses in photography. It can be used to describe the ratio between the darkest and lightest areas of a scene (essentially the contrast of the scene), whereby a scene with dark, dense shadows and piercingly bright highlights is said to be a high dynamic range scene. A scene where there is less difference between the brightness of the shadows and the highlights (such as on a foggy day) has a low dynamic range.

Dynamic range is also a description of the ability of a camera to record detail in both the highlights and shadows of a scene. The greater the dynamic range of the sensor, the more useful detail can be recorded in both. Ideally, the camera's dynamic range should match (or exceed) the dynamic range of the scene. However, this isn't guaranteed unless you are shooting in a studio where lighting is more easily controlled.

One of the skills necessary to master exposure is the ability to calculate when a scene's dynamic range could be problematic. Then, if it is, to determine whether remedial action can be taken or if a compromise in exposure is necessary.

Right: A scene's dynamic range is typically low when the light is soft. The dynamic range of this scene, which was shot on an overcast day, easily fitted the dynamic range of the camera.

Focal length: 200mm

Aperture: f/22

Shutter speed: 0.8 sec.

ISO: 100

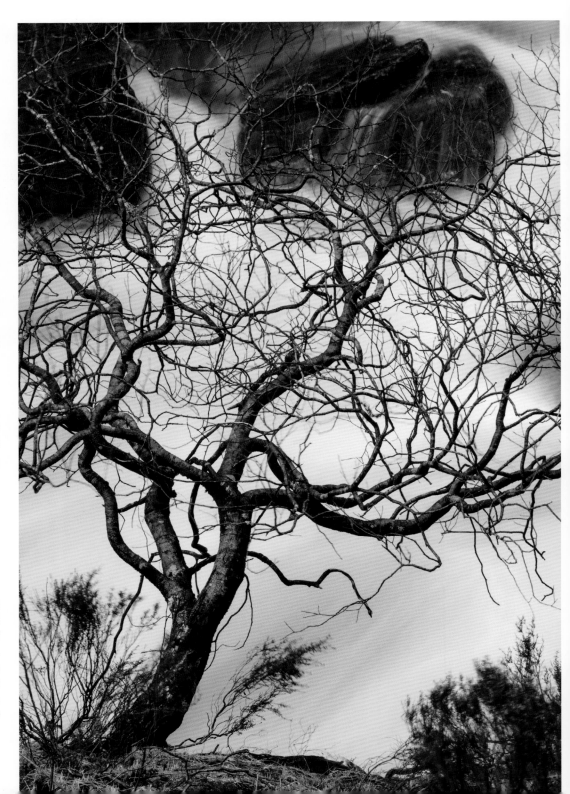

Tips

A very rough-and-ready way to determine whether a scene's dynamic range is an issue is to squint. If you can't see detail in the shadows (only in the highlights) then the dynamic range is likely to be high and potentially problematic.

A scene's dynamic range can be lowered by using reflectors, flash, or filters.

Modern DSLRs generally have a dynamic range of 10–14 stops, which is equivalent to a contrast ratio of 1024:1–16384:1.

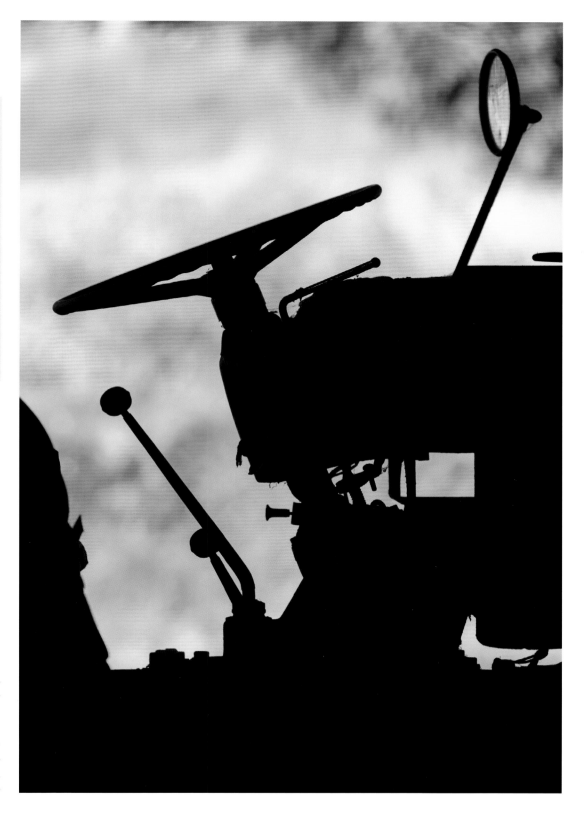

Right: Dynamic range is high when shooting scenes with uneven lighting across the picture space. This tractor was in heavy shadow, in front of a brightly lit background. The exposure choice I made was to expose for the background and let the tractor record as a silhouette.

Focal length: 200mm

Aperture: f/4.5

Shutter speed: 1/50 sec.

ISO: 100

Exposure Values

Theoretically, having an exposure meter built into a camera should mean that determining the correct exposure is painless. However, there are factors such as a scene's reflectivity that can skew the exposure suggested by the camera. With experience, it's possible to anticipate exposure errors and correct them before shooting; in fact, it's even possible to predict an exposure setting without the use of an exposure meter.

This is possible because the intensity of the ambient light illuminating a scene is always the same under certain conditions. This was recognized long ago and formed the basis of rules such as the "Sunny f/16 rule." The practical application of this is that a particular level of ambient light can be assigned a number referred to as an exposure value or EV.

For everyday shooting the most useful EV range starts at -5 and extends to 17; from conditions of near darkness through to scenes illuminated by extremely intense artificial lighting. If you can recognize the lighting situation you're shooting under, an EV allows you to make an informed decision on what combination of shutter speed, aperture, and ISO will produce a correct exposure.

The grid on the page opposite describes common lighting situations and their exposure value. To use the grid, first set the ISO on your camera to 100. Then, decide which exposure value most closely matches the lighting you're shooting under. Set the desired aperture on your camera and set the shutter speed shown where the exposure value and aperture intersect on the grid.

SUNNY F/16 RULE

On a sunny day, the shutter speed will always be similar to the ISO setting when the aperture is set to f/16. So, if the ISO is 100, the shutter speed will be 1/100–1/125 sec.; if the ISO is 200 it will be 1/200–1/250 sec; and so on. This was a popular (and surprisingly effective) way of calculating exposure before built-in exposure meters were commonplace in cameras.

EV 4 (BRIGHTLY LIT STREET SCENES)
f/16 @ 15 sec.

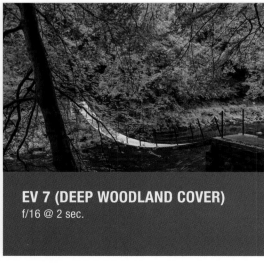

EV 7 (DEEP WOODLAND COVER)
f/16 @ 2 sec.

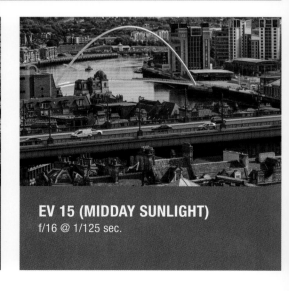

EV 15 (MIDDAY SUNLIGHT)
f/16 @ 1/125 sec.

EXPOSURE SETTINGS (ISO 100)

EV	F/1.4	F/2.0	F/2.8	F/4	F/5.6	F/8	F/11	F/16	
-5	1m	2m	4m	8m	16m	32m	64m	128m	Scene lit by crescent (quarter full) moon only; Aurora Borealis/Australis at medium brightness
-4	30s	1m	2m	4m	8m	16m	32m	64m	Scene lit by gibbous (half full) moon only; Aurora Borealis/Australis at maximum brightness
-3	15s	30s	1m	2m	4m	8m	16m	32m	Scene lit by full moon only
-2	8s	15s	4m	1m	2m	4m	8m	16m	Sand or snow scene lit by full moon
-1	4s	8s	15s	30s	1m	2m	4m	8m	Subject lit by ambient light from low brightness artificial light
0	2s	4s	8s	15s	30s	1m	2m	4m	Subject lit by ambient light from medium brightness artificial light
1	1s	2s	4s	8s	15s	30s	1m	2m	Distant cityscapes at night
2	1/2	1s	2s	4s	8s	15s	30s	1m	Moon fully eclipsed (as main subject); Lightning
3	1/4	1/2	1s	2s	4s	8s	15s	30s	Fireworks; Traffic trails
4	1/8	1/4	1/2	1s	2s	4s	8s	15s	Candle-lit subjects (in close-up); Floodlit buildings; Brightly lit street scenes
5	1/15	1/8	1/4	1/2	1s	2s	4s	8s	Dimly-lit domestic interiors; Night-time traffic
6	1/30	1/15	1/8	1/4	1/2	1s	2s	4s	Brightly-lit domestic interiors
7	1/60	1/30	1/15	1/8	1/4	1/2	1s	2s	Deep woodland cover; Illuminated indoor sports venues
8	1/125	1/60	1/30	1/15	1/8	1/4	1/2	1s	High brightness city scene; Bonfires
9	1/250	1/125	1/60	1/30	1/15	1/8	1/4	1/2	Spotlit subjects; Landscapes/cityscapes lit by pre-sunrise/post-sunset sky
10	1/500	1/250	1/125	1/60	1/30	1/15	1/8	1/4	Pre-sunrise/post-sunset sky
11	1/1000	1/500	1/250	1/125	1/60	1/30	1/15	1/8	Sunset sky; Subject in deep shade; Crescent moon (as main subject)
12	1/2000	1/1000	1/500	1/250	1/125	1/60	1/30	1/15	Outdoor light on a heavily overcast day (no shadows); Gibbous moon (as main subject)
13	1/4000	1/2000	1/1000	1/500	1/250	1/125	1/60	1/30	Outdoor light on a lightly overcast day (very soft shadows); Post-sunrise/pre-sunset sky
14	1/8000	1/4000	1/2000	1/1000	1/500	1/250	1/125	1/60	Weak sunlight (soft shadows); Full moon (as main subject)
15	–	1/8000	1/4000	1/2000	1/1000	1/500	1/250	1/125	Midday sunlight in bright or slightly hazy conditions (shadows visible)
16	–	–	1/8000	1/4000	1/2000	1/1000	1/500	1/250	Sand or snow under bright sunlight (hard-edged shadows)
17	–	–	–	1/8000	1/4000	1/2000	1/1000	1/500	Intense artificial lighting (dense, hard-edged shadows)

Color & Exposure

Colors (or "hues," to be more accurate) aren't equal in terms of the exposure needed. Very broadly, colors become paler and less saturated if overexposed, and richer and more saturated when underexposed slightly (there are limits however—all colors will bleach to white or turn black when over- or underexposed too far).

Certain colors, such as yellow, cannot be anything but bright—if you underexpose a yellow subject the color will shift toward brown/ocher. Other colors are more stable, though, so blue and red effectively stay blue and red, even when grossly underexposed.

Color accuracy is therefore an important consideration when setting exposure. There's nothing to say that color can't be shifted for effect by altering exposure, but accurate exposure (combined with an equally accurate white balance setting) is necessary when you want to retain a subject's true color characteristics. Ultimately, how you set your exposure for color will depend on whether accuracy or mood is more important.

Left: Brighter areas of an image—whether in terms of color brightness, color saturation, or exposure—are more eye-catching than darker areas (they are said to have a "higher visual weight"). Therefore, if your subject or focal point is darker or more drab than another area of an image, it may not have the compositional impact you intended. However, brightness can be used effectively as a compositional technique. To create this shot I deliberately aligned the leaves of this hawthorn bush against a bright, out-of-focus patch of light.

Focal length: 200mm

Aperture: f/3.5

Shutter speed: 1/320 sec.

ISO: 100

Above: Colors vary in their reaction to exposure adjustments: bright primary colors tend to stay truer for longer as exposure is adjusted.

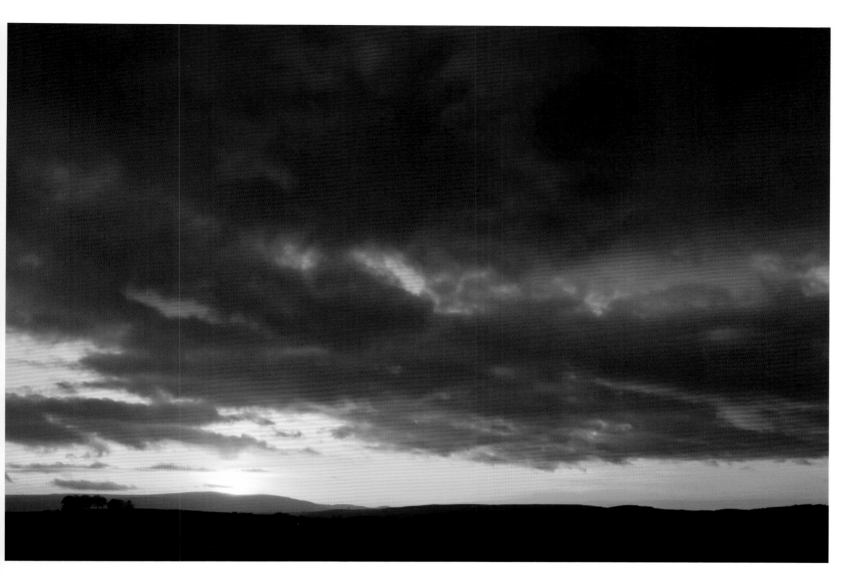

Above: A colorful sunset requires careful thought when it comes to the exposure. If you overexpose, the colors will appear washed out, particularly paler colors close to the horizon, so the correct exposure or even slight underexposure is preferable. The range of tones when shooting directly toward the sun will generally exceed a camera's dynamic range. For this reason, foreground areas will lack detail.

Focal length: 22mm

Aperture: f/10

Shutter speed: 1/100 sec.

ISO: 100

Chapter 3

Controlling Exposure

Once the basics of exposure have been grasped, it's time to start taking control. Controlling exposure requires knowledge of the various options your camera offers that affect exposure. This includes seemingly unrelated choices, such as whether you shoot JPEG or Raw, the shooting mode you select, and how the camera meters a scene.

Fortunately, although this takes time, it is knowledge that can be applied no matter what camera you use in future; technology may be refined over time, but the basic principles of exposure rarely change.

Right: Some situations require you to quickly alter your camera settings or risk missing the moment. A good working knowledge of my camera let me do just that when shooting this image. However, one useful habit is resetting your camera to a familiar configuration (what this is will depend on your style of shooting). This means you always start from a useful base that you can deviate from when necessary.

Focal length: 20mm

Aperture: f/8

Shutter speed: 1/250 sec.

ISO: 100

Exposure Workflow

Creating an image with a digital camera is an exercise in capturing digital data in the form of pixels. Ideally, the quality of the pixel data captured and stored on a memory card should be the maximum achievable by the camera. The more that pixel data is degraded or compromised, the less scope there will be to make adjustments during postproduction. Although you may think that postproduction isn't necessary, there's nothing to be gained by constraining your options at the time of shooting.

There are many ways that pixel data can be degraded: the file type you choose is one, and an incorrect exposure setting is another (although ETTR is one exception to this rule—see pages 106–107). Developing a shooting workflow is therefore a good habit to acquire. A usable workflow should feature key steps, from pre-shooting through to postproduction. The workflow will then help you decide which camera settings are most appropriate to maximize the quality of the pixel data captured. One possible workflow is shown to the right, but this can be modified according to your particular shooting style.

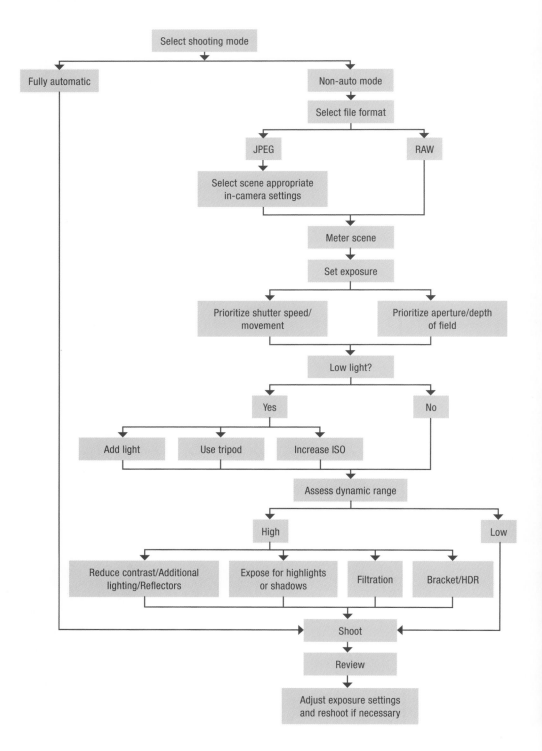

MIRROR SLAP/SHUTTER SHOCK

Occasionally, your camera will cause the shooting of less-than-optimal pixel data. If you shoot with a DSLR, "mirror slap" can be a significant cause of image softness. As the name suggests, mirror slap is caused when the reflex mirror swings upward at the start of an exposure. This mechanical action can cause vibrations to shake the camera slightly, producing a visual effect similar to camera shake. The solution is to use a camera's mirror lock option (where available), which swings the mirror up before exposure. Alternatively, you can switch to Live View.

"Shutter shock" is similar in effect, but is caused by the mechanical movement of the shutter curtains. Shutter shock can affect both DSLRs and mirrorless cameras, although some cameras feature electronic shutters that eliminate this problem entirely.

Right: As a personal preference I'd rather take my time over a shot if possible. This means I can think about both the required exposure and the type of lighting that would be most appropriate for the subject. Still life is one genre where that level of control is possible.

Focal length: 15.7mm

Aperture: f/5

Shutter speed: 5 sec.

ISO: 80

Above: Some situations require an instinctive way of shooting. This is mainly when events move so quickly that you don't have time for a considered approach. This image was "shot from the hip," with the camera set to Program so I could concentrate on the action rather than fine tuning the exposure.

Focal length: 100mm

Aperture: f/4

Shutter speed: 1/1600 sec.

ISO: 100

Right: Sometimes a scene presents many challenges, and exposure decisions need to be made quickly, before the moment is lost. This scene was challenging due to the extremes of contrast. Without additional lighting it was impossible to balance the exterior and interior light levels, so the compromise made was to expose for the subject in the knowledge that the exterior would be burnt out and the interior shadows would be dark and lacking in detail.

Focal length: 35mm

Aperture: f/6.3

Shutter speed: 1/8 sec.

ISO: 1250

File Formats

All but the most basic digital cameras offer you the choice of shooting either in JPEG, Raw, or both. Which option you choose depends on your attitude to postproduction and the amount of control you want over how your image is processed.

JPEG

The JPEG format is a compressed file format that is compatible with virtually every type of software that accepts images. This includes image-editing programs and other types of software, such as word processors. JPEG is also the standard file format used to display photos on the Internet.

JPEG images are processed in-camera. After shooting, the camera applies and "bakes" settings such as the selected white balance into the image. This makes it difficult to remove these settings in postproduction without an unacceptable loss of image quality. When shooting JPEG, the decision about how an image should look is therefore made before shooting, not afterward; the reverse is true of shooting Raw.

In terms of exposure, there are several camera settings that should be carefully thought about before shooting. The most important is... exposure. There is less latitude for correction in postproduction when shooting JPEG, so your exposure needs to be as accurate as possible to avoid the need to make extensive adjustments later. For this reason, techniques such as ETTR (see pages 106–107) are not suitable when you are shooting JPEGs.

Because of the greater need for exposure accuracy, an argument can made that you have to be a "better" photographer when shooting JPEG compared to Raw. Other settings that need to be chosen carefully include long exposure and high ISO noise reduction (see pages 54–55), highlight and shadow control, lens corrections, and picture parameters (see pages 70–71).

Above: It's generally possible to shoot JPEG and Raw simultaneously. The penalty is that a memory card is more quickly filled. However, having an image ready for immediate use, as well as one that can be polished at leisure, is often useful.

COMPRESSION

Images can be compressed to save space on your memory card or hard drive. There are two basic methods of compressing image data: lossless and lossy. Lossless compression reduces the file size without losing any detail in the image. When the file is uncompressed, the image is as good as it was at the time of shooting. By comparison, lossy compression removes fine details in order to reduce file size: the higher the level of compression, the greater the loss of detail.

Both Raw and JPEG files can be compressed. Raw files are usually compressed using lossless compression (though there are rare exceptions to the rule), while JPEGs are compressed using a lossy compression method.

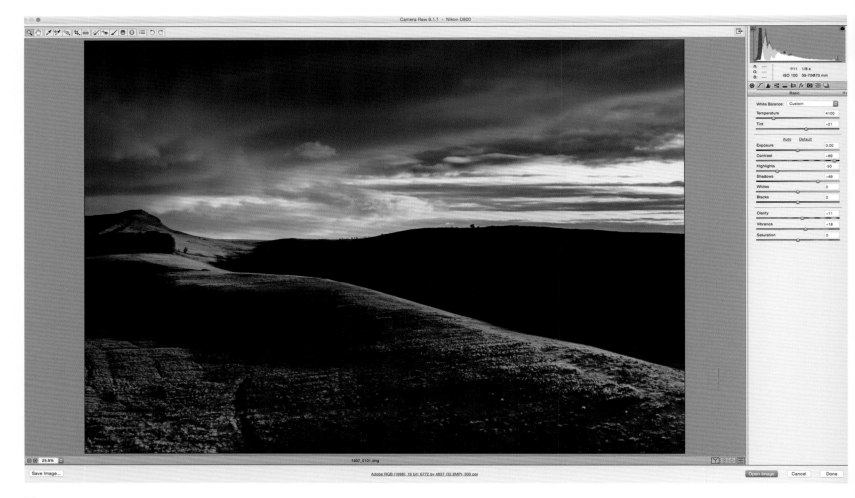

Raw

A Raw file is essentially a packet containing all the image data captured by the camera at the moment of exposure. Unlike JPEGs, this packet can only be opened by dedicated Raw-editing software. Once opened, the Raw file then needs to be exported as a more useful file-type—such as JPEG or TIFF— before it can be used freely in other software.

You may ask why you'd want to add an extra step into your workflow—why not shoot JPEGs and save time? This is a good question, as you not only need to export the Raw file, but it also needs a certain amount of processing. This includes setting white balance, adjusting contrast and sharpness, and other corrections, such as removing lens aberrations.

All this means that producing a finished photograph when shooting Raw can be very time consuming. However, it also gives you the greatest level of control over how you interpret an image— the possibilities are endless and not constrained in the way that shooting JPEGs is. What's even more useful is the data in the Raw file is never altered, so you can reset your changes endlessly, without any loss of quality.

Depending on the Raw conversion software you use, the changes you make to a Raw file are either stored in a sidecar file or in a database of changes.

Above: If you adjust a Raw file using software such as Adobe's Camera Raw (shown above), the software notes the changes you make. A file containing a list of those changes is then saved into the same folder as your Raw file. This is known as a "sidecar file," which shares the same name as the Raw file, except for an .XMP file extension. When you next open the Raw file, the editing software reads the accompanying .XMP file and applies the changes made previously; subsequent changes are also added to the .XMP file. However, if the .XMP file is deleted or separated from the Raw file, the changes you've made will be lost. So, if you move the Raw file to another folder, the .XMP file should also be moved.

CUSTOM PICTURE PARAMETER
Low contrast; Low color saturation

LANDSCAPE PICTURE PARAMETER
High contrast; Increased saturation of greens and blues

NEUTRAL PICTURE PARAMETER
Low–medium contrast; Low–medium color saturation

PORTRAIT PICTURE PARAMETER
Medium contrast; Naturalistic skin tones

STANDARD PICTURE PARAMETER
Medium contrast; Medium color saturation

VIVID PICTURE PARAMETER
High contrast; High color saturation

saturation set at their lowest values. Although the resulting image will appear flat and washed-out in playback, it will give you a better idea of whether detail has been retained in both the shadows and highlights. During postproduction, the image can be styled as desired.

Tips

Camera manufacturers use different terms for picture parameters: Nikon uses Picture Control, Canon uses Picture Style, and Sony uses Creative Style to name just three.

A "flat" picture parameter is particularly useful when shooting using the ETTR technique (see pages 106–107).

Exposure Modes

With the exception of the most basic models, the majority of cameras offer a range of exposure modes that let you choose how automated the exposure process is. To master exposure fully, you need to consider carefully which exposure mode is most relevant to achieving the desired outcome.

Fully Automatic

This option is referred to by different names depending on the camera manufacturer, but the concept is similar to all. Fully automatic (Auto) mode puts the camera in full control of exposure, from setting the aperture, shutter speed, and ISO, to other shooting parameters, such as noise reduction and highlight/shadow optimization. Generally, the only options that you can change are the drive mode and image quality settings—and sometimes even those are heavily restricted.

This makes Auto less then ideal if you want to make any creative decisions other than an image's composition. On the positive side, Auto makes shooting a far more fluid process. This is useful in social situations, such as weddings or parties, when capturing the spirit of the event has a higher priority than technique.

Right: Shooting fast-moving or unique events often leaves little time to adjust exposure. Program mode takes the worry out of exposure, but still gives you the option of tweaking settings if need be.

Focal length: 31.5mm

Aperture: f/4.5

Shutter speed: 1/950 sec.

ISO: 400

Program

A step-up from Auto is Program (commonly shortened to P). Program is also an automated mode, but it has far greater built-in flexibility than Auto. Set to Program, the camera will initially select what it considers to be the most appropriate combination of shutter speed and aperture; usually with the shutter speed biased to a relatively high value to reduce the risk of camera shake. However, unlike Auto you have the option to modify the exposure, usually by adjusting the ISO setting, applying exposure compensation, and/or shifting the paired shutter speed and aperture settings. This makes Program a good first step toward taking control of your exposures.

Shutter Priority

Shutter Priority mode is a semi-automatic shooting mode. When Shutter Priority is selected you choose the shutter speed (and ISO setting) and the camera sets the required aperture value.

As the name suggests, this is the mode to use when you want to prioritize control over shutter speed and how movement is captured, rather than depth of field. Shutter Priority is ideal for shooting subjects such as fast-moving sports, for example.

There is a drawback, however. Cameras typically have a greater range of shutter speeds compared to the range of available aperture settings. In bright or low light this means it's all too easy to set a shutter speed that requires an aperture that simply isn't available. This results in either underexposure (when the aperture required is larger than the lens' maximum) or overexposure (when the aperture required is smaller than the lens' minimum). Shutter Priority often requires an increase in the ISO setting or the use of ND filters (see pages 132–133) so that an available aperture can be selected.

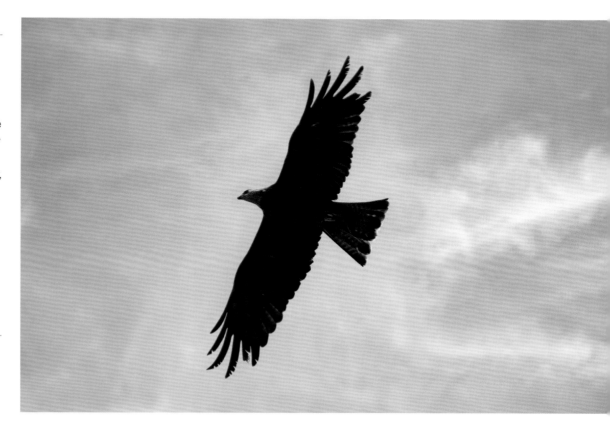

NAMING CONVENTIONS
A frustrating aspect of photography is that manufacturers often use different terms for common functions. The shortened forms of Shutter Priority and Aperture Priority are a good example. Nikon, Fuji, Olympus, Panasonic, and Sony shorten these two functions to S and A respectively; Canon and Pentax use Tv and Av (for Time Value and Aperture Value).

Above: To capture a fast-moving subject with pin-sharp detail you need to sacrifice depth of field in order to maximize the shutter speed. This means that your focusing needs to be precise, particularly when your subject is relatively close to the camera.

Focal length: 70mm

Aperture: f/2.8

Shutter speed: 1/800 sec.

ISO: 800

Aperture Priority

Aperture Priority is the exact opposite of Shutter Priority; you choose the required aperture (and ISO), leaving the camera to select the shutter speed. Aperture Priority is the mode to select when controlling depth of field is more important than the way in which movement is captured.

Photographers most likely to use Aperture Priority are landscape and architectural photographers, as these two genres typically involve using smaller apertures to maximize depth of field. Portrait photographers will also find Aperture Priority useful, but in this instance larger apertures may be preferable to minimize depth of field and soften the background behind the portrait subject.

Right: A typical scene when Aperture Priority is indispensable. There is little movement (other than the clouds), so the shutter speed is relatively unimportant. However, the scene is very three-dimensional, with both foreground and background elements that need to be sharp. This requires the use of a relatively small aperture to extend depth of field from the front through to the back of the scene.

Focal length: 30mm

Aperture: f/8

Shutter speed: 1/450 sec.

ISO: 200

Manual

Switch to Manual exposure mode and any exposure automation is abandoned (with the exception of Auto ISO), so both the shutter speed and aperture must be set manually on the camera before shooting.

There are advantages and disadvantages to using Manual. The big disadvantage is that it's far easier to incorrectly expose an image than when shooting in any of the other exposure modes. This is a particular risk if the light levels alter significantly between you setting the exposure and taking your shot (a distinct possibility when shooting outdoors or when shooting multiple images over a long period of time). Incorrect exposure can also result when filters are fitted after the exposure has been set and the filter factor is not taken into account (see page 130).

The main advantage of Manual exposure is that the exposure you set is effectively in permanent exposure lock. This is ideal when shooting under consistent light levels, as it means that the exposure won't change between shots if the average reflectivity of a scene alters as you shoot or if you move the focus point.

Another advantage of Manual exposure is that there's greater scope for creative under- or overexposure than with the other exposure modes. Although exposure compensation can be set when using Program, Shutter Priority, and Aperture Priority, you will be limited to the range of adjustment allowed by the camera, which may only be ±3 stops.

When setting the exposure manually, your camera's meter can be used as a guide, or you can use a handheld light meter, reading the values from the meter and setting them on your camera (see page 82). However, if you are shooting over a long period of time it's worth taking new meter readings occasionally to check that the exposure is still correct.

Above: Manual exposure is ideal when consistency is paramount. This is the case when shooting a sequence of shots to stitch into a panoramic image in postproduction; the less exposure adjustment you need to make during postproduction, the better the quality of your final image.

Focal length: 200m

Aperture: f/11

Shutter speed: 1/20 sec.

ISO: 100

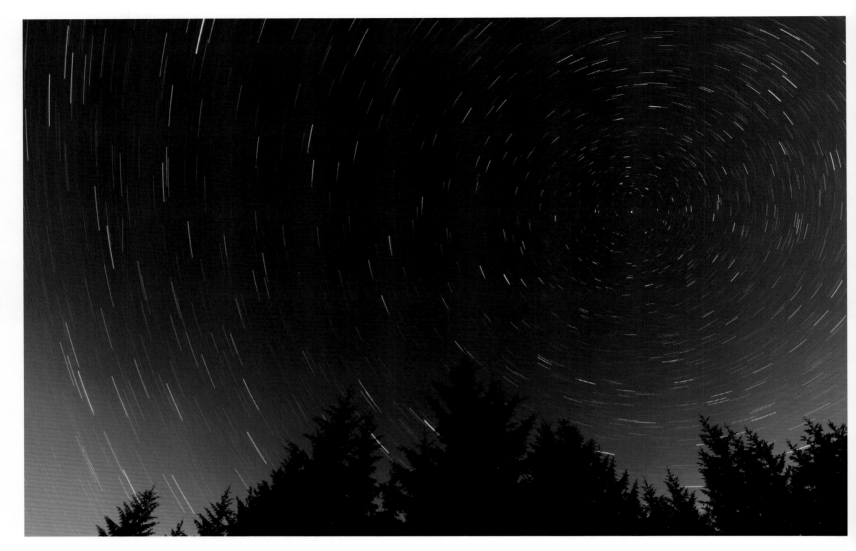

Bulb

In all the exposure modes described so far you are generally limited to using shutter speeds that are 30 seconds or less. Bulb (B) mode is designed to let you shoot images that require a shutter speed longer than 30 seconds.

Shooting using Bulb mode requires the use of a remote release with a shutter-lock function. This lets you lock the shutter open for as long as required, without the need to keep the camera's shutter-release button physically held down (which would become very tiring, very quickly). Some cameras also feature a Time (T) mode, which is

a variation of Bulb: one press of the shutter-release button locks the shutter open and a second press of the shutter-release button closes it.

The most difficult aspect of using Bulb is determining the correct amount of time for an exposure: the camera's metering system is of limited use once the shutter speed exceeds 30 seconds. One method is to use the EV table on page 59 as a guide. Another method (assuming you use the camera's base ISO for the final exposure) is to temporarily switch to Aperture Priority and select the aperture you would like

to use. Then, increase the ISO on your camera until a 30 second exposure is possible. Calculate the number of stops difference between the camera's base ISO and the selected ISO. Switch to Bulb, set ISO to the base setting, and use the grid opposite to calculate the time that the shutter should be locked open for.

Above Left: Bulb is typically used when ambient light levels are very low or you are using extremely strong light-sapping filters. When using Bulb it's possible to lock the shutter open for minutes, or even hours—the limitation is the battery life of the camera (although this is less of a problem with film cameras).

Focal length: 20mm

Aperture: f/8

Shutter speed: 21 min.

ISO: 800

Tip

Not all cameras feature Bulb mode. Compact cameras, for example, often limit the maximum shutter speed to a relatively low value, such as 1 second. Fortunately, shooting multiple images consecutively and then blending them in postproduction can achieve a similar effect.

Above: Aperture Priority is probably the most useful exposure mode for landscape photographers, where front-to-back sharpness is generally desirable. This allows the viewer of the image to feel as though they could step into the scene. However, there's no reason not to use larger apertures in order to restrict depth of field and emphasize particular parts of a scene.

Focal length: 70mm

Aperture: f/4

Shutter speed: 1/50 sec.

ISO: 500

ISO DIFFERENCE	1 stop	2 stops	3 stops	4 stops	5 stops	6 stops
EXPOSURE TIME	1 min.	2 min.	4 min.	8 min.	15 min.	30 min.

Metering

There are two ways to measure light levels: incident metering and reflective metering. The former measures the intensity of light falling onto a scene being photographed, while the latter measures the amount of light reflected by the scene. This is a subtle, but important difference.

Reflective Metering

The light meters built into cameras use reflective metering. The advantage of having a meter built into a camera is that you obviously don't need a separate handheld meter, but reflective metering has a one serious disadvantage: it's affected by the reflectivity of the scene being metered.

Reflective metering works on the principle that a scene has an overall average reflectivity that is equivalent to a mid-gray. The scene therefore neither reflects most of the light back toward the camera nor fully absorbs that light. This principle works well if the scene being metered is averagely reflective, but there will be times when a scene is less than obliging.

A scene that has higher-than-average reflectivity—a scene dominated by light tones, such as snow, sand, or a portrait of someone with very pale skin—will cause a reflective meter to underexpose. This is because the meter is suggesting an exposure that lowers the dominant lighter tones to the mid-gray ideal. When a lower-than-average scene is metered the reverse occurs: the meter will try to raise the dominant darker tones to a mid-gray, overexposing the image.

A camera's evaluative metering mode (see page 80) is often sophisticated enough to recognize problematic scenes, but there has been no camera meter developed yet that isn't fooled occasionally. Learning to recognize when techniques such as exposure compensation (see page 84) may be necessary is a useful skill to acquire.

Incident Metering

Handheld light meters (with the exception of handheld spot meters) are incident meters. Typically, an incident light meter is used to take a meter reading from the subject position. This means that for certain subjects—a distant landscape lit differently to the location of the camera for instance—incident light meters aren't suitable. However, when it's practical to use an incident light meter the benefit is exposure accuracy—incident light meters aren't affected by the reflectivity of the scene in the way that reflective meters are. For more details on how to use an incident light meter see page 82.

Tips

A simple way to make reflective metering more accurate is to meter from a photographic gray card. See page 83 for details.

On some camera models, spot meter readings can be taken from the active focus point. As with standard spot metering, you still have to be aware of whether the spot-metering target is (or should be) a midtone.

Spot metering isn't always an option. Some cameras feature "partial" metering, which has a slightly larger metering area.

Camera Metering Modes

Most cameras have a variety of different metering modes to choose from that work in subtly different ways to read the light—if you use the wrong metering mode, you may find that your images are exposed incorrectly. Knowing which metering mode to use (and when) is an important step in the process of mastering exposure.

EXPOSURE LOCK

Exposure lock—often abbreviated to AEL—lets you hold the exposure settings for a fixed period of time, allowing you to recompose a shot after taking a meter reading, without the camera altering the exposure. Exposure lock can either be activated by pressing the shutter-release button down halfway (and keeping it held down), or by pressing a dedicated exposure lock button on the camera body.

Right: Working out the distribution of tones in an image is more easily achieved after shooting. First convert the image to black and white. Then, using postproduction software, either heavily blur the image or use a pixelation tool (as shown here).

Finally, click on various points around the image to "read" the tones. A midtone has an RGB value of 127, 127, 127; a value significantly higher than this is a light tone, while anything lower is a dark tone (black and white are 0, 0, 0 and 255, 255, 255 respectively). Experimenting with different images is a good way of understanding the tonal range of images and how they were exposed.

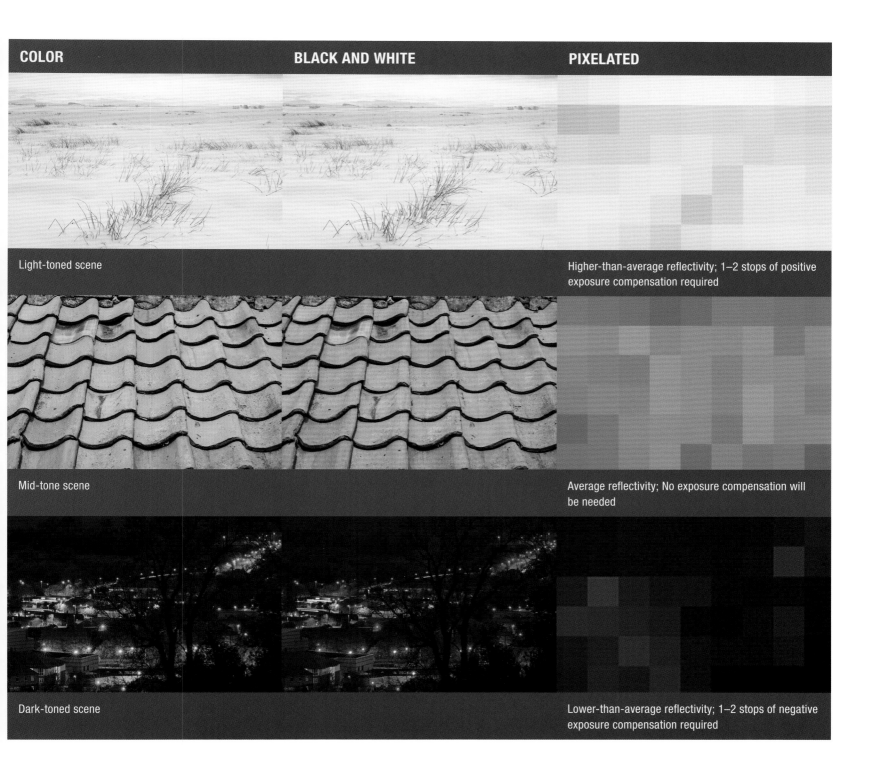

COLOR	BLACK AND WHITE	PIXELATED

Light-toned scene

Higher-than-average reflectivity; 1–2 stops of positive exposure compensation required

Mid-tone scene

Average reflectivity; No exposure compensation will be needed

Dark-toned scene

Lower-than-average reflectivity; 1–2 stops of negative exposure compensation required

Evaluative Metering

The default metering mode on all modern cameras is evaluative metering (which, to confuse matters, is also known as multi-zone, matrix, or multi-pattern metering, depending on the camera brand used). The biggest strength of evaluative metering is that—more often than not—it's accurate and produces pleasing exposures.

Evaluative metering works by dividing the frame into rows and columns of individual cells or zones. When the metering is activated, each cell measures the amount of light falling onto it. The camera then assesses the result from each cell and an overall exposure is calculated.

Different manufacturers use different methods for assessing the metering information, but a common approach is to look for a pattern in the relative brightness metered by the cells across the image. The pattern can then be compared with a database of commonly encountered lighting situations. For example, if most of the cells near the top of the image show a bright reading, but the bottom cells show a darker reading then it's likely that the scene being metered is a landscape. By making an intelligent guess in this way the camera can bias the exposure in an appropriate manner.

A recent variation of this approach is to weight the exposure toward the focus point, the theory being that where you focus is probably the most important element of the scene. This technology is sophisticated, but it's not foolproof. One problem with evaluative metering is that it isn't always consistent, which makes predicting how it will meter a scene difficult. When moving the focus point between two elements in a scene that have different levels of reflectivity the exposure settings can alter markedly (when using an automatic or semi-automatic exposure mode).

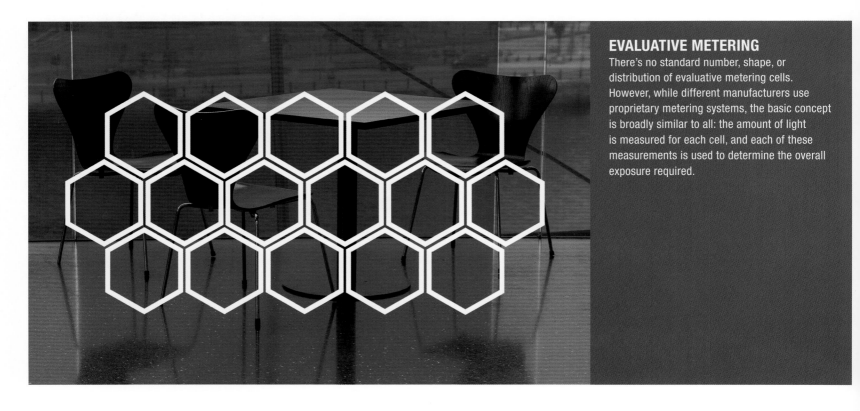

EVALUATIVE METERING

There's no standard number, shape, or distribution of evaluative metering cells. However, while different manufacturers use proprietary metering systems, the basic concept is broadly similar to all: the amount of light is measured for each cell, and each of these measurements is used to determine the overall exposure required.

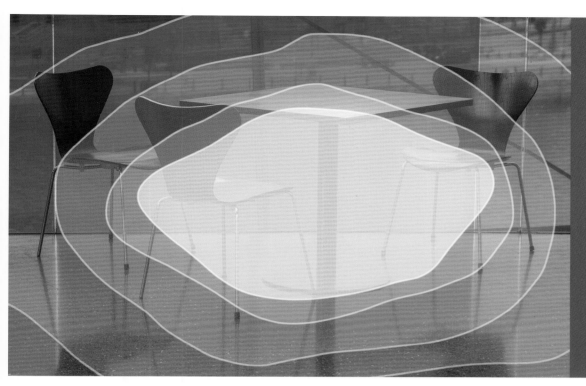

CENTER-WEIGHTED METERING

Center-weighted metering is an older technology than evaluative metering. Despite this, it's still occasionally useful, as once you've learned its quirks it's often easier to predict how it will meter a scene compared to evaluative metering.

As with evaluative metering, center-weighted metering assesses the entire scene. However, the light reading is biased more by the center of the scene than the edges (but in a far less precise way than spot metering, described below). The amount of bias depends on the camera used, but 60% is a common figure.

SPOT METERING

This option allows you to meter from a small area of a scene, typically within a delineated section at the center of the viewfinder or LCD screen. The size of the spot metering area varies between cameras, but it's usually within 1–5% of the viewfinder/LCD frame.

Spot metering gives you more control over where your meter reading is taken from than either evaluative or center-weighted, but the key skill is judging whether your metering target is a midtone (or should be a midtone in the final image). If you meter from an area that has higher- or lower-than-average reflectivity you will need to apply exposure compensation.

Handheld Light Meters

Handheld light meters often have several different metering options, including basic incident metering and flash metering. However, the common factor in all these options is that you set two of the three exposure controls on the meter—shutter speed, aperture, and ISO—and then measure the ambient light falling on your subject to determine the third. Typically, when using a handheld meter your camera would be set to Manual exposure mode. Once you've taken the meter reading all three exposure control values shown on the meter should be set on the camera (taking account of filter factors if filters are fitted to the camera—see page 130).

1 Set the light meter to the required mode— either to measure ambient light or flash. Select whether you want the meter to display the required shutter speed, aperture, or ISO after taking a reading.

2 Set the two desired exposure control values so that they're the same on both the light meter and camera (for example, if you want the light meter to show you the required shutter speed, set the desired aperture and ISO values on the camera and light meter).

3 Hold the light meter in front of your subject, pointing the lumisphere toward the camera.

Above: Using a handheld light meter is particularly useful when shooting a subject that has higher- or lower-than-average reflectivity. This set of books had a 1-stop lower-than-average reflectivity, which didn't affect the exposure reading I took with a handheld meter.

Focal length: 28mm

Aperture: f/5

Shutter speed: 2 sec.

ISO: 80

4 Press the metering button on the light meter to take your light reading.

5 Transfer the suggested exposure reading to your camera.

Tips

Once you've taken an exposure reading you can adjust either of the two set exposure controls and the meter will update the required third control without needing to take a new reading.

Some light meters have retractable lumispheres. This should be retracted when measuring the light falling onto a two-dimensional subject.

You can usually remove or slide back the lumisphere. This allows you to take reflected readings by aiming the light meter toward the subject (although this has the same limitations as the meter in a camera).

Gray Card

A gray card is a photographic accessory that can be used to make reflected meter readings more accurate. Usually this would be used in conjunction with the camera's built-in meter, but gray cards can also be used with handheld meters.

As the name suggests, the card is a mid-gray that reflects approximately 18% of the light falling on it. The idea is that the meter reading is taken from the gray card, rather than the scene itself. The card should be held in the same light as the scene and either fill the viewfinder frame (when using evaluative metering), or be at the center of the viewfinder (when using center-weighted, partial, or spot metering modes).

Don't shade the gray card with your body when you use it, and hold the gray card so that it is as evenly lit as possible, to ensure an accurate reading. As with using a handheld meter, the gray card technique is most successful when using Manual exposure mode.

Right: A gray card is most useful if you're not sure where to take a spot meter reading from in a scene. This can happen when a scene appears to be comprised entirely of shadows and highlights, with few midtones—such as this skeleton on a black background.

Focal length: 28mm

Aperture: f/3.2

Shutter speed: 1/40 sec.

ISO: 80

Modifying Exposure

When shooting using modes such as Program or Shutter Priority, the exposure can be modified so that it's different to the exposure initially selected by the camera. The two main functions for doing this are exposure bracketing and exposure compensation. Larger cameras often have physical dials or buttons on the camera body and menu options that let you set these functions, while smaller cameras generally rely on menu options.

Although the two functions are subtly different, bracketing and compensation are often combined so that either or both can be set from the same menu screen.

Exposure Compensation

Exposure compensation lets you override the exposure selected by the camera in Program, Aperture Priority, Shutter Priority, and—depending on the camera—other modes, such as Auto. The only modes that generally don't allow the use of exposure compensation are Manual exposure and Bulb (as you are free to adjust the exposure).

Typically, the exposure can be adjusted in ⅓-, ½-, or 1-stop increments up to ±3 stops (sometimes even ±5 stops). This wide range of adjustment makes it easy to correct any metering errors introduced by the camera. With practice, it's possible to assess a scene visually and dial in an approximately correct exposure compensation value before shooting. This is particularly useful if you don't have time to refine your exposures and need to shoot quickly.

One important habit to acquire is resetting exposure compensation back to its 0 value once it's no longer required. Generally, cameras "remember" how exposure compensation is set when they're switched off. This means it's all too easy to begin shooting again later with an incorrect level of exposure compensation.

Left: One of the most useful applications for exposure compensation is correcting exposure errors caused by scenes with a higher- or lower-than-average reflectivity.

Focal length: 100mm

Aperture: f/8

Shutter speed: 1/6 sec.

ISO: 100

Above: How an image is exposed (or altered in postproduction) affects how that image is perceived emotionally. The slight underexposure of this image suits the sinister connotations of the security camera.

Focal length: 200mm

Aperture: f/5

Shutter speed: 1/800 sec.

ISO: 100

Bracketing

A camera's bracketing function lets you shoot three or more images, each with a different exposure setting. Typically, the first exposure in the sequence is shot at the "base" exposure (this is either the standard exposure or the compensated exposure if exposure compensation has also been set). The second and third images are under- and overexposed variations of the base exposure; the degree of under- or overexposure is set in EV increments before shooting.

Bracketing shots is a useful insurance policy, as it means you have a choice as to which is the most successful exposure in the sequence. The downside to bracketing shots is that it's all too easy to fill a memory card unnecessarily quickly. You will also have to spend time later working through and weeding out all the undesirable images. Bracketing should therefore be used sparingly and only when the "correct" exposure is difficult to determine.

Tips

If you use bracketing in conjunction with your camera's self-timer, the camera will shoot the required number of bracketed images automatically, one after the other. This is commonly known as Automatic Exposure Bracketing (AEB).

When shooting using Shutter Priority the camera will alter the aperture when exposure compensation is applied; when using Aperture Priority, the shutter speed is adjusted.

A less common option is bracketing the ISO setting. This is occasionally useful, as it means you can maintain the same shutter speed and aperture settings.

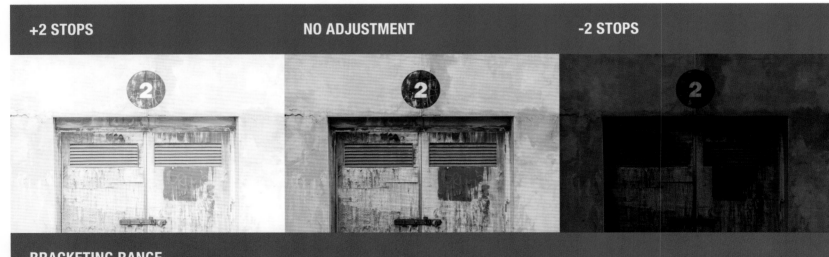

+2 STOPS **NO ADJUSTMENT** **-2 STOPS**

BRACKETING RANGE
How great the variation in the bracketed exposures should be is largely down to the dynamic range of the scene you're shooting and your camera. A high dynamic range scene and low dynamic range camera would benefit more from a wide variation in the exposures. This sequence shows a bracketing range of ±2 stops.

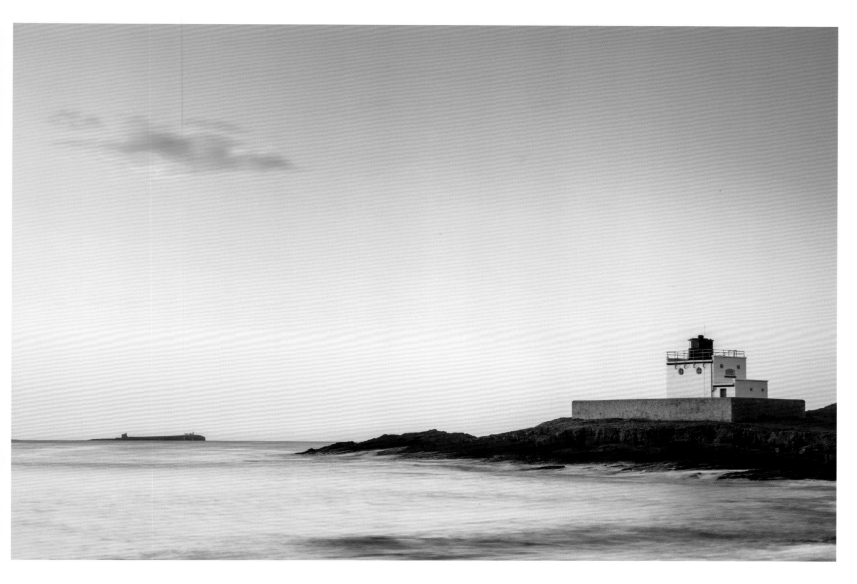

Above: Exposure compensation is an invaluable tool when shooting scenes that don't have average reflectivity. This brightly lit scene, dominated by a pale sky, required 1 stop of positive compensation. Shooting in Aperture Priority mode, the camera extended the shutter speed to adjust the exposure.

Focal length: 60mm

Aperture: f/22

Shutter speed: 3 sec.

ISO: 100

Above: There's no shame in bracketing if the optimal exposure settings are difficult to determine. If you can spare the memory card space, bracketing also allows you to use postproduction techniques such as HDR (see pages 164–165).

Focal length: 40mm

Aperture: f/22

Shutter speed: 3 sec.

ISO: 100

Histograms

An extremely useful tool on a camera is the image histogram, which provides an accurate way to assess whether your exposures are correct or not (as long as your preview image is accurate; see page 70).

A histogram is a graph with two axes, which shows the complete luminance or tonal range of an image in pictorial form. The horizontal axis shows the luminance range of the image from black (the shadows) at the left edge to white (the highlights) at the right edge, with pixels of average luminance (equivalent to mid-gray) at the center. The vertical axis shows the number of pixels of a specific luminance in the image.

One myth about histograms is that they should peak in the middle like a bell distribution curve, which would indicate that the image was mainly comprised of pixels of average luminance. In fact there's no ideal shape for a histogram; it is only ever a guide to the luminosity range of the image.

Generally, a histogram that is skewed dramatically to the left warns that an image is underexposed, while a histogram skewed to the right often indicates that an image is overexposed. However, you have to decide whether the histogram is revealing an exposure error, or is simply showing that the image has a predominance of dark pixels because the subject is naturally dark, or a lot of light pixels because the subject is light.

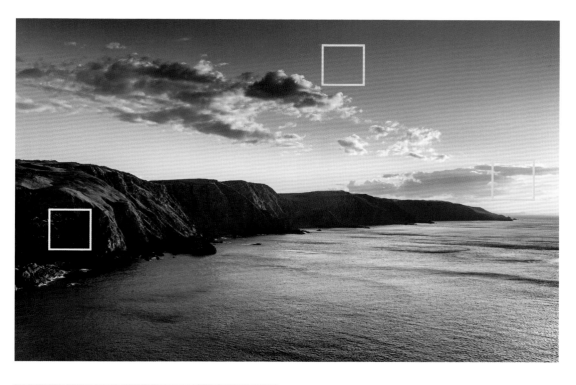

Above & Left: With practice it's possible to match up areas of an image with the relevant part of a histogram. In this image the colored boxes match the similarly colored areas of the image's histogram.

Focal length: 35mm

Aperture: f/11

Shutter speed: 1/60 sec.

ISO: 100

RGB HISTOGRAM

Some cameras let you display an RGB histogram that shows the mix of red, green, and blue in an image. This is less useful for assessing exposure than a luminance histogram (described above), but it can be used to determine whether the white balance is accurate.

Tip

Sometimes it's impossible not to clip the highlights. This generally occurs when bright point light sources (such as the sun) are included in your shot. The only way to avoid clipping this type of lighting would be to grossly underexpose the rest of the image.

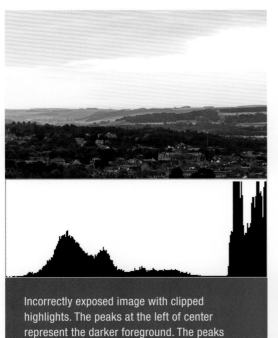

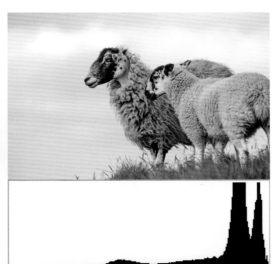

When a histogram leans against either the left or right edge of the scale, it shows that the shadows or highlights are clipped respectively. When clipping occurs you need to adjust the exposure; applying positive compensation to recover shadow detail or negative compensation to recover the highlights. When both ends of the histogram are clipped, the scene being recorded exceeds the dynamic range of the camera. In this instance you have to make a decision whether retaining shadow or highlight detail is more important to the success of the image. Usually, retaining highlight detail is preferable, as burnt-out highlights are visually more distracting than dense shadows.

Incorrectly exposed image with clipped highlights. The peaks at the left of center represent the darker foreground. The peaks at the right of the histogram represent the pale, burnt-out sky.

Correctly exposed image with predominance of pixels lighter than mid gray. Note how the histogram is skewed to the right, but it is not clipping the right edge. This shape of histogram is typically seen with high-key images (see pages 102–103).

Tip

The problem with assessing a Raw image's histogram is that it isn't necessarily a true reflection of the tonal range of the file. You actually view a JPEG version of the Raw file created by applying in-camera processing options (see pages 70–71).

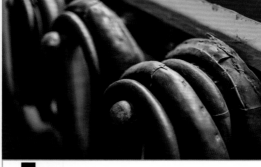

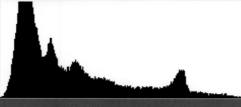

Incorrectly exposed image with clipped shadows. With the exception of the specular highlights, most of the tones in this image are darker than a mid-gray.

Correctly exposed image with predominance of pixels darker than mid gray. The histogram is skewed to the left, but it is not clipping the left edge. This shape of histogram is typically seen with low-key images (see pages 100–101).

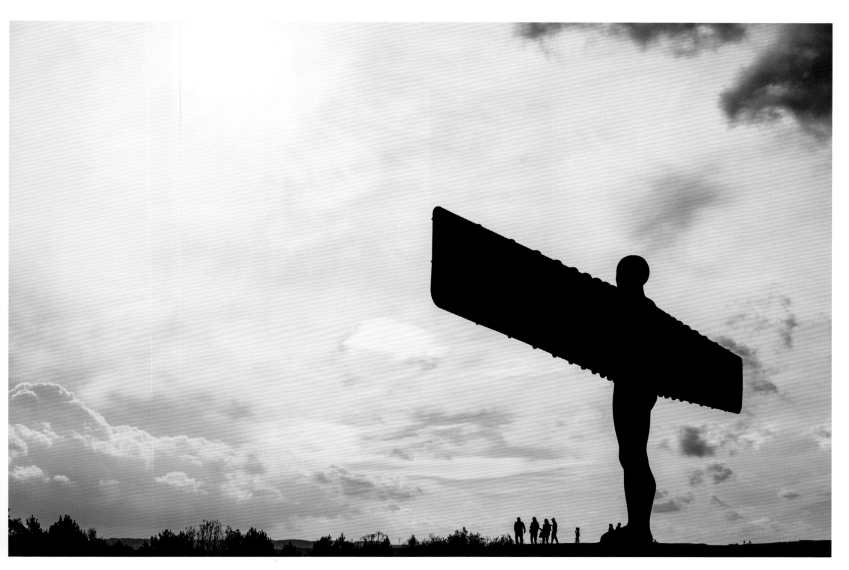

Above & Left: A histogram can be used to judge contrast in an image. Two large, separate peaks in a histogram are a good indicator of high contrast. The further apart the peaks are (the closer they are to the left and right edges), the higher the contrast. This high-contrast image is mainly comprised of dark and light tones, with few midtones.

Focal length: 50mm

Aperture: f/13

Shutter speed: 1/400 sec.

ISO: 100

The Zone System

The Zone System of exposure was developed in the 1930s by the American photographers, Ansel Adams and Fred Archer (although it was based on work by other photographers prior to this).

The fundamental basis of the Zone System is that the tonal range of a scene can be divided into 10 different zones, ranging from Zone 0 (pure black with no detail) through to Zone IX (pure white with no detail). However, the Zone System goes much further than a simple description of tonal range—it is a methodology of photographic practice that takes account of both exposure and the development of the silver halide emulsion.

The Zone System was devised in an era when the only shooting medium available was black-and-white silver halide emulsion, used to coat either celluloid film or glass plates. When using the Zone System for this purpose you first have to pre-visualize how the scene being photographed would look as a print in terms of brightness and contrast. You then decide where tones in the scene would be placed compared to the tones in the Zone System range. Finally, you expose and develop your negative according to the first two stages. By altering both the exposure and development time of film stock it's possible to alter both the brightness and contrast of the final image so that it matches your original pre-visualization.

Of course, most of this is irrelevant to digital photography, but an understanding of how a scene can be broken down into zones and how this relates to the histogram is still a useful skill to acquire.

Zone 0
Pure black; No recoverable detail

0% Reflectance

Zone I
Almost black; Little discernible detail

1% Reflectance

Zone II
Detail just visible

2.25% Reflectance

Zone III
Shadows with some textural detail; Muddy color

4.5% Reflectance

Zone IV
Typical shadow brightness

9% Reflectance

Zone V
Mid-tone; Dark skin; Green grass

18% Reflectance

Zone VI
Caucasian skin

35% Reflectance

Zone VII
Light tone; Pastel colors

72% Reflectance

Zone VIII
Lightest tone with discernible detail

95% Reflectance

Zone IX
Pure white; No recoverable detail; Specular highlights

100% Reflectance

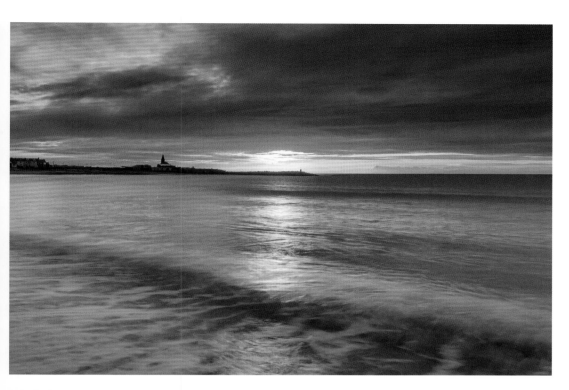

Left: Each zone is equivalent to 1 stop of exposure. However, the zones are more compressed at either end of a histogram (and compressed more in the shadows than the highlights).

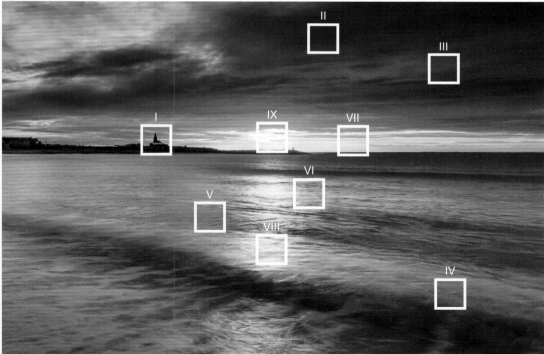

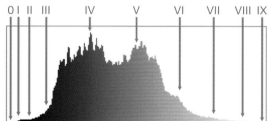

Left & Above: It's easier to visualize how the various zones equate to a black-and-white image than one in color. However, the Zone System can be used when shooting either.

Focal length: 35mm

Aperture: f/16

Shutter speed: 1 sec. (with 3-stop graduated filter)

ISO: 100

Chapter 4
Creative Exposure

Once the basics of exposure have been mastered you can become more playful and experimental with your photography. Although it's often desirable to get your exposures technically correct, there's no reason why an image can't be overexposed or underexposed, or extremes of exposure used (such as using maximum or minimum aperture or an extremely fast or slow shutter speed). In this chapter we'll explore some of the ways you can be creative with your exposure and the challenges that this often brings.

Right: Working under natural light requires flexibility, as you have less control over the brightness or quality of the light than when shooting in a studio. This means that happy accidents often occur that—if not planned—produce unexpectedly pleasing results. With this shot of a solar eclipse, the cloud cover initially seemed to be an impediment to shooting. Fortunately, the cloud was thin enough that the eclipsed sun backlit it, creating a more atmospheric image than originally planned.

Focal length: 200mm

Aperture: f/22

Shutter speed: ¼ sec. (with 10-stop ND graduate filter)

ISO: 100

Multiple Exposures

A multiple exposure is a photograph created by blending two or more images together, either in-camera or later in postproduction. The main appeal of using multiple exposures is that it produces off-kilter images that often look surreal and otherworldly.

Creating in-camera multiple exposures is relatively easy when shooting film. All that's required is that the same film frame is held in place without advancing until the multiple exposure process is complete. This isn't possible when shooting digitally, so multiple exposures are only possible if it's an option on a camera's shooting menu. If not, then creating a postproduction blend is the only choice.

Shooting multiple exposures on film requires some thought. You first need to decide how many times the same film frame will be exposed. Meter normally and note the overall required exposure. Then set the exposure you shoot at as the required exposure divided by the number of times the film frame is exposed. For example, if you want to make an image composed of two exposures, each individual exposure should need to make up ½ of the overall required exposure; if you want to combine three exposures then each would need to form ⅓ of the exposure, and so on.

Your camera's digital multiple exposure mode (if it has one) is far easier to use, as these calculations are usually taken care of automatically.

Above: A thematic link between multiple exposures isn't a necessity, but it can be very effective. The link in this multiple exposure image is the statue of Neptune, Roman god of the sea, and the choppy surface of a nearby river.

Focal length: 135mm

Aperture: f/8

Shutter speed: 1/250 sec.

ISO: 100

Tip

Shooting a silhouetted subject against a light, almost burnt-out background and then combining it with a darker, textural subject works particularly well; the texture will only be seen in the silhouetted area of the original exposure.

Time Lapse

A time-lapse sequence is comprised of hundreds (even thousands), of images shot individually at regular intervals over a reasonably lengthy period of time. The images are then combined chronologically into a movie. The result is that time appears to be compressed, so what took hours will flash by in minutes or seconds.

Shooting images to create a time-lapse video takes some planning. The first aspect to consider is the subject. Static subjects or subjects that move extremely slowly aren't suitable for the time-lapse treatment. Nor are subjects that move extremely quickly. Depending on the shutter speed used and the interval between individual images, fast-moving subjects may not be recorded at all. Popular subjects for time-lapse videos are natural landscape and built environments. Not only do elements of these environments move—clouds, people, traffic, and so on—but the light level and shadow length also changes as the sun tracks across the sky, which adds visual interest.

The key part of shooting a time-lapse sequence is consistency. There is no rule as to how long the interval between the shooting of individual images should be, but once you've started shooting, the interval should not be varied. If you change the time between shots as you shoot, movement in the resulting movie will appear to randomly speed up or slow down. See the grid above right for suggested intervals based on subject matter.

Shooting at precise, regular intervals requires an intervalometer. Some cameras have a built-in intervalometer that allows you to specify the interval time between shots, as well as the number of exposures the camera will make. Alternatively, you can use a remote release with a similar function or fire the shutter manually, using a stopwatch to keep track of time. If in doubt, shoot with a shorter interval rather than a longer one, as you can always cut out images later if need be. By shooting more images than necessary, you'll also have the option of deliberately varying the speed

INTERVAL TIME	SUBJECT
1 second	Street scene with traffic; Fast-moving clouds
2 seconds	Street scene with people
3 seconds	Sunrises; Sunsets; Sun/moon close to the horizon
5 seconds	Clouds
10 seconds	Slow-moving clouds
20–30 seconds	Night sky or landscape
10–20 minutes	Building construction

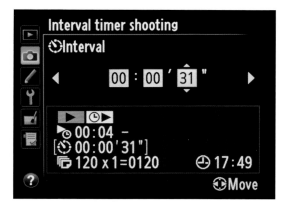

Above: A camera with a built-in intervalometer will allow you to shoot time-lapse sequences without the need for any extra equipment, such as a specialist remote release.

Tips

Use a heavy tripod to avoid any camera movement while you shoot the sequence.

Switch to Live View or use mirror lock-up when using a DSLR. This will cut out any vibration caused by "mirror slap."

of the sequence at relevant points in the movie. This is known as "speed ramping." Temporarily ramping up the speed of a movie is an effective way of skipping through less interesting sections.

Movies are replayed either at 25 frames per second (in territories such as Europe, which use the PAL TV standard) or 30 frames per second (in NTSC territories, such as Northern America and Japan). To shoot a sequence that will last a specific period of time, multiply the number of seconds you want your time-lapse movie to run for by either 25 or 30 (for PAL or NTSC playback respectively). This will give you the number of individual images you need to shoot.

The length of time (in seconds) that will be needed to actually shoot those images can then be calculated. Do this by first adding the camera's shutter speed to the interval time. Next, multiply this figure by the number of images required. The time taken to shoot the sequence should be considerably longer than the length of the finished movie. If it isn't, then you'll need to revisit your calculations. To capture a specific timed event, such as a sunrise, you'll need to be aware of the capture time and be ready to start long before the event begins.

When you're ready to shoot, switch to Manual exposure mode and set the correct exposure

with a fixed ISO setting—if you shoot using an automated exposure mode the exposure may vary considerably between shots, creating a distracting flickering effect during the movie. However, if you think that light levels may vary considerably over the course of the shoot (at sunrise or sunset, for example) use Aperture Priority. In either case, you don't want to use a shutter speed that's longer than your selected interval, so set the shutter speed to be—at most—50-70% of the interval time. A good starting point for the shutter speed is 1/50 sec., although it pays to experiment, depending on the light levels and the speed of any movement in the scene.

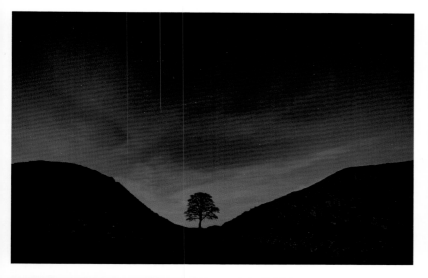

Shooting in Raw will give you more latitude for exposure correction in postproduction, but remember that any corrections you make should be applied consistently across the image sequence. Calculating the number of images as described opposite will also tell you whether your memory card has enough space to shoot the entire sequence.

You should select manual focus and focus before you begin to shoot, as consistency in the focus is as important as consistency in the shooting interval and exposure. Finally, you can set your intervalometer and begin shooting.

Above Left to Right: Selected frames from a time-lapse sequence lasting 90 minutes. Due to the shutter speed of 30 seconds, long exposure noise reduction was switched off before shooting. When the sequence is run, the stars arc around the Pole Star above the tree at the center of the frame.

Focal length: 10mm
Aperture: f/4
Shutter speed: 30 sec.
ISO: 200

Low Key

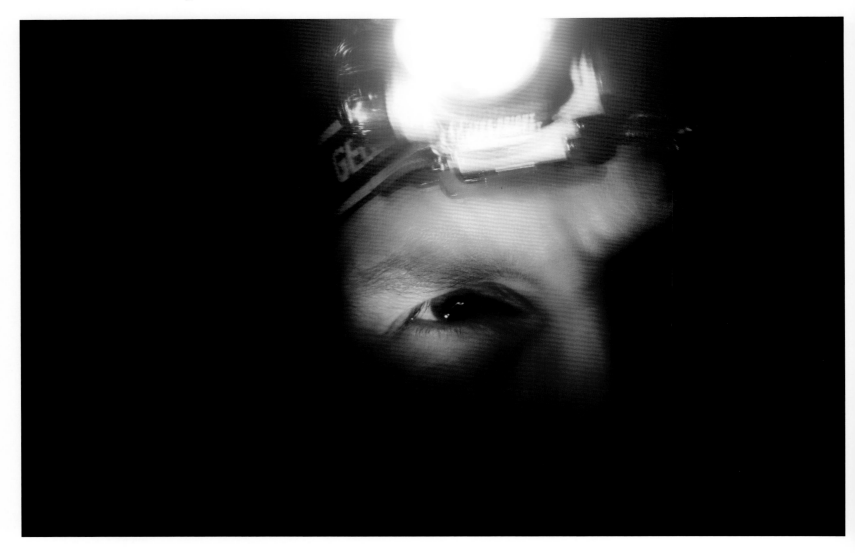

A low-key image is one that is comprised mainly of dark tones (those that are darker than a midtone). Low-key imagery tends to be moody, with a weighty, even portentous feel. This makes low-key photographs suitable for conveying emotions such as sadness, fear, and solemnity, as well as concepts such as masculinity; you wouldn't shoot low-key imagery to make someone smile in delight.

You'd be forgiven for thinking that all it takes to create a low-key image is to use underexposure.

This would certainly skew the tonal range toward the darker tones, but successfully creating low-key images requires the control of light, rather than exposure (although some exposure adjustment may be needed at the shooting stage); deep, dark shadows are important in the creation of the low-key look.

For this reason, low-key images can be more easily created when shooting with just one light source (add another light source and the shadows

Above: When working indoors you need to control ambient light. This either means waiting until it's dark or using heavy drapes over windows.

Focal length: 100mm

Aperture: f/10

Shutter speed: 4 sec.

ISO: 400

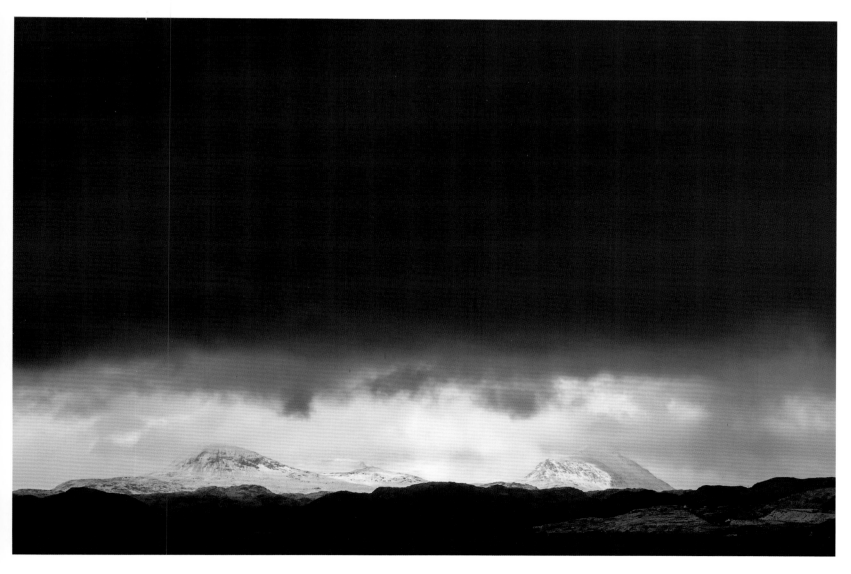

may be lightened too far). When metering, you need to decide what the brightest tone in the shot should be, and set your exposure accordingly. This is most easily achieved using spot metering and exposure compensation. Using evaluative metering when shooting low-key images will generally result in exposures that are brighter than desirable.

Above: Filters such as ND graduates can be used to create low-key effects. Here, a 2-stop ND graduate filter was used to darken the stormy sky dramatically, so that it was far darker than was strictly natural. To set the exposure, a spot meter reading was taken from the sunlit strip close to the bottom of the frame.

Focal length: 70mm

Aperture: f/11

Shutter speed: 1/100 sec. (with 2-stop ND graduate filter)

ISO: 100

High Key

A high-key image is the exact opposite of a low-key image, so is dominated by light tones (those that are lighter than a midtone). Shadows—if there are any—are open and generally diffuse. High-key imagery is by its very nature light and airy, and is often used to add a romantic atmosphere to portraits. It can also help to convey innocence, optimism, and femininity.

Overexposing an image will produce a high-key effect, but the problem with this approach is that it's all too easy to burn out the highlights—even when shooting high-key imagery it's better to retain as much tonal information as possible at the time of shooting. Therefore, as with shooting low-key images, careful and thoughtful control of light will produce a more pleasing and successful effect (and reduce the risk that highlights will blow out unnecessarily). When shooting in a high-key way, the light you use should be soft and even—low contrast is desirable. It can often be necessary to add extra illumination to lighten shadows, which can be achieved through the use of more than one light source or by using reflectors to bounce light into the shadow areas.

As with low-key shooting, you should meter for the brightest area of the scene. However, you would set the exposure so that the highlights are as bright as possible without clipping. Again, this is easier when using spot metering, allowing for the fact that the exposure suggested will generally require positive compensation.

Right: Reflective surfaces help to push light into the shadows. The water's surface in this shot acted as a large reflector, reducing contrast and allowing a high-key approach without the need for additional equipment.

Focal length: 200mm

Aperture: f/5

Shutter speed: 1/125 sec.

ISO: 100

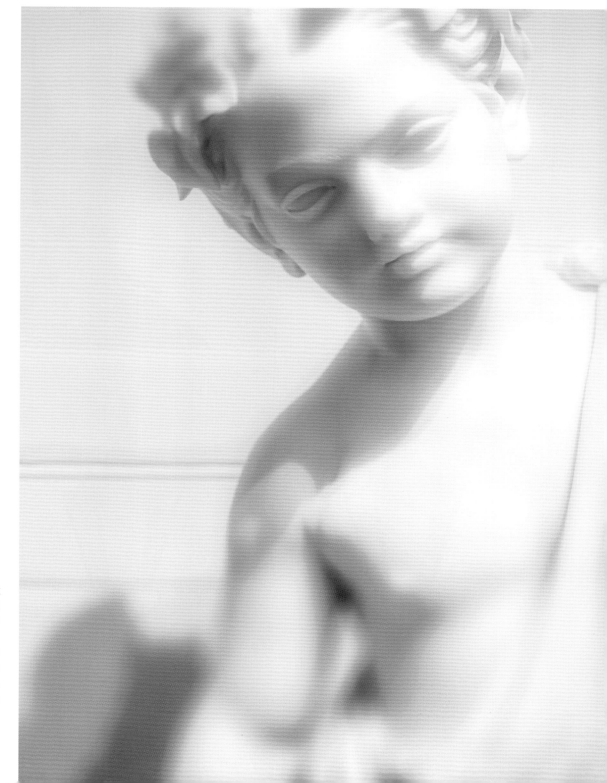

Right: Soft-focus filters—whether fitted to the camera at the time of shooting or applied in postproduction—tend to lighten shadows. This helps to create a slightly dreamy, romantic high-key effect.

Focal length: 28mm

Aperture: f/4.5

Shutter speed: 1/50 sec.

ISO: 400

Silhouettes

A silhouette is an image in which the subject is represented as a shape with no detail other than its outline. Shooting a backlit subject and setting the exposure so that the background is correctly exposed, rather than the subject, usually creates a silhouette, and means the subject is dark in tone, or even completely black.

How dark a silhouette is at the time of shooting is dependant on a number of factors. The greater the difference in the relative brightness of the subject to the background, the more pronounced the silhouette effect will be. How an image is exposed will also determine the effectiveness of the silhouette. Basing the exposure on a spot meter reading from the background will ensure that the subject won't influence the exposure (and risk overexposing the background). Alternatively, applying 1- to 2-stops of negative exposure compensation will override the tendency for evaluative metering to try and expose your main subject correctly.

Above: Silhouettes are easier to create when the strongest light source is directly behind the subject. When shooting outdoors, this generally means shooting early or late in the day, when the sun is close to the horizon.

Focal length: 28mm

Aperture: f/14

Shutter speed: 1/340 sec.

ISO: 200

Left: Cameras with a high dynamic range can sometimes make it difficult to produce true silhouettes at the time of shooting—it's the one time when retaining visible detail in the shadows is undesirable. Depending on the camera, creating a silhouette may therefore require a substantial increase in contrast during postproduction.

Focal length: 200mm

Aperture: f/5.6

Shutter speed: 1/750 sec.

ISO: 100

Generally, the stronger and more recognizable the shape of the subject, the more effective the silhouette will be; faces work better when shot in profile, rather than straight on, for example.

Keeping a composition simple is beneficial too. Silhouettes composed of two or more subjects that overlap are harder to read visually, so choosing

a shooting angle that allows a gap between the various elements will make it easier for the viewer to recognize what those elements are.

Above: Shooting a sunrise or sunset produces vibrant backgrounds for silhouettes. However, the cloud that is colored by the sun can also act as a fill light, reducing the effectiveness of the silhouette.

Pentax 6x7 with Fujifilm Velvia 50 film; exposure unrecorded.

ETTR

Due to the nature of digital sensors there is always more useful image data captured in the highlights of an image (provided they aren't clipped) than the shadows. Lightening dense shadows in postproduction to reveal detail often reveals unwanted noise instead, but "exposing to the right" (ETTR) is a shooting technique that maximizes information in the shadow areas.

Shooting ETTR

The simplest way to shoot using ETTR is to apply positive exposure compensation when shooting. The aim is to set the exposure so that the image histogram is skewed as far to the right as possible, without the highlights clipping (hence the name). Exposing in this way will result in an image that appears pale and washed out on the camera's LCD screen. However, this is rectified in postproduction, when the exposure is normalized and contrast added if required.

The main point of shooting ETTR is that maximum detail is retained in the shadows. Even though shadows may be subsequently darkened in postproduction, exposing to the right gives you the option of how light or dark you make the shadows, without noise reducing image quality.

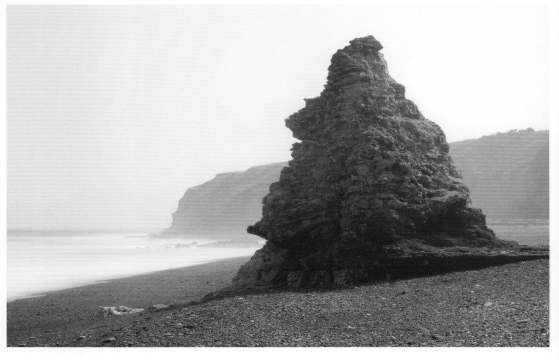

Tips

To set an ETTR exposure, apply positive exposure compensation based on a Live View histogram. If your camera can't display a Live View histogram, shoot a test image, assess it alongside its histogram in playback, and reshoot with a modified exposure.

Bracketing will give you a useful safety net when shooting ETTR if you have sufficient memory card space. Set the bracketing amount to ⅔-stop above and below your ETTR exposure setting.

When shooting ETTR you effectively shoot at an ISO lower than the set ISO. If the dynamic range of the scene allows, shooting ETTR is an effective method of using either a longer shutter speed or larger aperture than a standard exposure.

Above: It's important when shooting ETTR to avoid clipping the histogram at the right edge. This image was close to clipping, but I was confident that the full tonal range had been captured.

Focal length: 80mm

Aperture: f/11

Shutter speed: 20 sec. (with 10-stop ND filter)

ISO: 100

When Not To Shoot ETTR

ETTR isn't recommended for every shot. In fact, in certain situations it's not recommended at all. It should only be considered when shooting Raw, for example, as JPEGs don't have the same usable tonal range and are more prone to clipping.

ETTR is also not suitable when contrast is high and a scene's dynamic range is greater than the camera can capture without clipping (for this reason ETTR is more often possible with a system camera than a compact camera).

The ideal scene for ETTR is when a standard exposure results in a gap at the right end of the histogram. The width of the gap is a good indication of how much deliberate overexposure can be applied. The narrower the gap, the less room there is for exposure adjustment and the less effective ETTR will be.

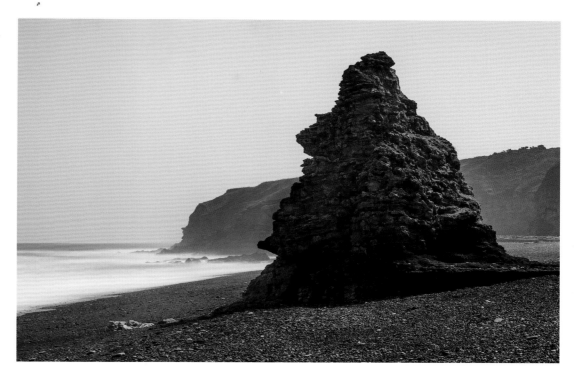

Above: ETTR images need to have their exposure normalized in postproduction. It's also often necessary to boost contrast and increase color saturation. The result is an image with greater punch and a wider range of tones.

Above: We tend to look at the highlight areas of images more readily than the shadows. Specular highlights, being typically bright white, can therefore be distracting. However, some types of highlights, such as the sun or bright point light sources need to be close to or even pure white. They would look unnatural if the exposure was set so they were closer to mid-gray.

Focal length: 70mm

Aperture: f/8

Shutter speed: 1/250 sec.

ISO: 100

Above: Freezing blink-and-you'll-miss-it movement requires the fastest shutter speed possible. It also requires high light levels, or a wide aperture, or an increase in the ISO (sometimes even both). For this shot, the camera was set to continuously fire as waves crashed against a rocky shore. Because I used a large aperture (reducing depth of field), the focus also had to be precise. This was achieved by pre-focusing and holding focus as I shot.

Focal length: 200mm

Aperture: f/3.5

Shutter speed: 1/5000 sec.

ISO: 100

Chapter 5
Practical Exposure

Photography often involves finding solutions to a series of problems. Fortunately, many photographers will have faced those same problems before, so there are numerous techniques that can be read about and applied to virtually all photographic situations. This chapter covers some of the problems you may face on your journey to mastering exposure and—more importantly—how they can be solved.

Right: Macro photography brings a series of exposure challenges that are subtly different to "normal" shooting. Not only is depth of field more restricted, but the degree of magnification will also alter the exposure settings required. However, these are challenges to which solutions can be readily found.

Focal length: 100mm

Aperture: f/22

Shutter speed: 1/125 sec.

ISO: 200

Optical Problems

There's no such thing as a perfect lens. Lenses are rated in terms of qualities such as resolution (or sharpness), contrast, and lack of chromatic aberration, but these aren't fixed qualities; they are variable and alter according to the aperture setting used. Lenses often have what's known as a "sweet spot," which is a particular range of aperture settings (or a single aperture setting) that produces the highest optical quality that the lens is capable of.

Lens Resolution & Contrast

The resolution of a lens is a measurement of the amount of detail it is capable of resolving clearly, while contrast is the ability of a lens to separate different tones, such as black and white. Both resolution and contrast can be measured by the number of line pairs—a series of vertical black and white lines—that can be resolved per millimeter (shown as lp/mm). The higher the lp/mm figure, the higher the resolution of the lens and the better its contrast.

However, the maximum resolution and contrast of a lens isn't always consistent across the image space; resolution is generally higher at the center of the image than it is at the edges.

Lens resolution and contrast are also typically lower across the whole of the projected image at both maximum and minimum apertures, reaching a peak when the mid-range apertures are used (the "sweet spot"). To complicate matters, the sweet spot isn't necessarily the same for the center as the corners, so the image quality at the center of the frame may be at its highest with one aperture setting, while the image quality at the edges is better at an alternative aperture setting.

Large Aperture Problems

There are various types of imperfections that—to a greater or lesser extent—affect all lenses at apertures close to their maximum setting. These imperfections include vignetting, chromatic aberration, and coma. Fortunately, the problems of a particular model of lens can be quantified and then reduced or even removed entirely in-camera when shooting JPEGs (see page 70) or during postproduction when shooting Raw.

Vignetting is seen as a darkening around the edges and corners of an image, which is most noticeable at the widest aperture settings. It is reduced as the aperture is stopped down, and

Above: The resolution of a lens is typically at its lowest at the extremes of the aperture range.

Focal length: 100mm

Aperture: f/3.5

Shutter speed: 1/90 sec.

ISO: 100

Tip

Using a lens at maximum aperture is a true test of its optical quality. Most modern lenses perform well at their "sweet spot," but a truly good (and often expensive) lens will also exhibit fewer problems at maximum aperture than a poor lens.

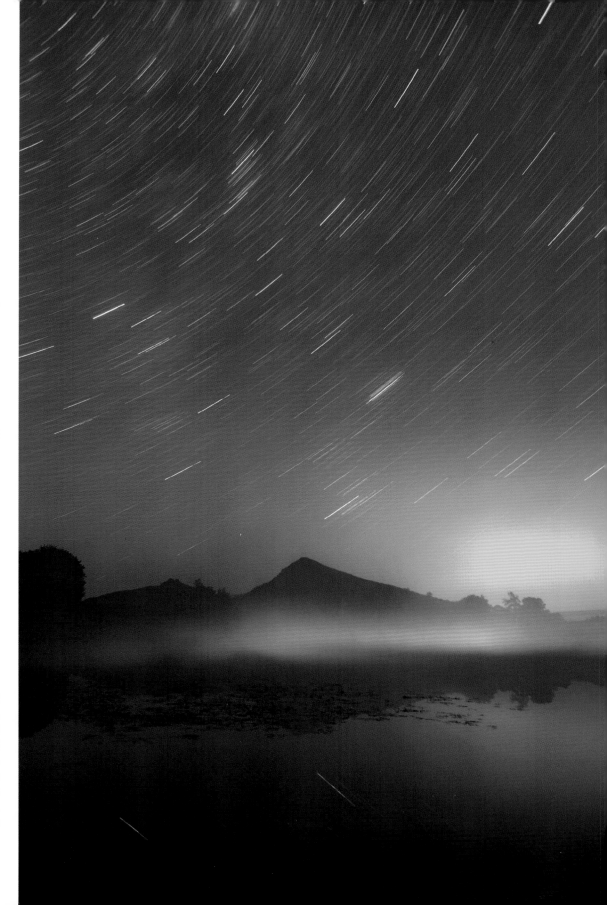

is generally no longer visible when mid-range apertures are selected.

Chromatic aberration is seen as colored fringing along high-contrast edges in an image. It's caused by the inability of a lens to bring all the wavelengths of light to focus at the same point on the sensor.

There are two types of chromatic aberration: axial and transverse. Axial chromatic aberration is seen across the entire image and is most prominent when a lens is set to maximum aperture. The appearance of axial chromatic aberration is reduced as the aperture is stopped down.

Transverse chromatic aberration is only seen at the edges of an image and isn't reduced by adjusting the aperture. Apochromatic lenses feature special optical elements that help to cut down the occurrence of chromatic aberration.

The effect of lens coma (or "comatic aberration") is mainly seen when shooting point light sources off-axis—typically around the edges of an image—where it causes a tail-like structure to emanate from the light source (similar in appearance to a comet, which shares the same etymology). As with the flaws described previously, the effects of coma are reduced and usually eliminated as the aperture is made smaller.

Right: Shooting star trails means using large apertures to gather as much light as possible during the exposure. The flaws of this lens can be seen at the corners of the image, where the star trails are far softer and diffuse than those in the center.

Focal length: 20mm
Aperture: f/4
Shutter speed: 18 min.
ISO: 800

Bokeh

The Japanese word "bokeh" is often misused to describe the fact than an image has an out-of-focus background. However, the true meaning of bokeh is more subtle. It should correctly be used to describe the esthetic qualities of the out-of-focus highlight areas of an image.

A lens can be described as having "good bokeh" or "bad bokeh," depending on how pleasing or not the out-of-focus highlights are. As a general rule, prime lenses usually have more pleasing bokeh than zooms.

All lenses vary in how they render the out-of-focus areas of an image. Factors that influence this include the number of aperture blades in a lens and the ability of a lens to suppress chromatic aberrations. Theoretically, out-of-focus highlights in an image should be spherical, but the use of relatively few aperture blades in a lens (usually for cost reasons) results in out-of-focus highlights that appear polygonal or distorted.

Another common problem is that out-of-focus areas have a "nervous" quality and don't look as smooth as they should. Out-of-focus highlights can also have a quality described as onion-like, in which the highlights aren't uniform and vary in brightness as though made of layered rings (just like an onion when it's chopped in half).

Good lens reviews often comment on the qualities of a lens' bokeh, but this is ultimately subjective: unless you peer closely at your images, the qualities may or may not be noticeable at normal viewing distances.

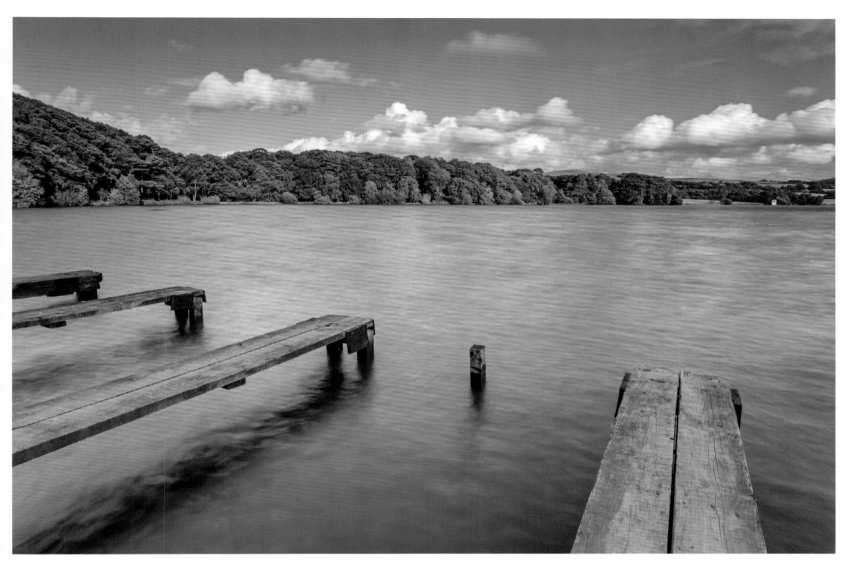

Left: Out-of-focus backgrounds are most often seen when shooting with long focal length lenses at their maximum aperture. This requires precise focusing so the subject is pin-sharp. The bokeh of this lens is arguably only average—there is an obviously hexagonal quality to the out-of-focus highlights.

Focal length: 200mm

Aperture: f/3.3

Shutter speed: 1/8000 sec.

ISO: 100

Above: Shot at the lens' minimum aperture, this image suffers from diffraction. The result is smoother, less textural detail in the distant trees and foreground boat platforms. The lens' minimum aperture was used to achieve a lengthy shutter speed, but in this situation a better method would have been to use an ND filter.

Focal length: 20mm

Aperture: f/22

Shutter speed: 3.2 sec.

ISO: 50

Small Aperture Problems

Depth of field is at its maximum extent when a lens is set to its smallest aperture. Unfortunately, this isn't the way to achieve maximum sharpness. As the aperture is made smaller, beyond the "sweet spot," the resolution of the lens declines. This results in the softening of fine detail and a loss of clarity. The reason for this decline is due to an increase in the effects of diffraction.

The smaller the aperture is, the more the image-forming rays of light are randomly scattered by the aperture blades and so diverge (or, more

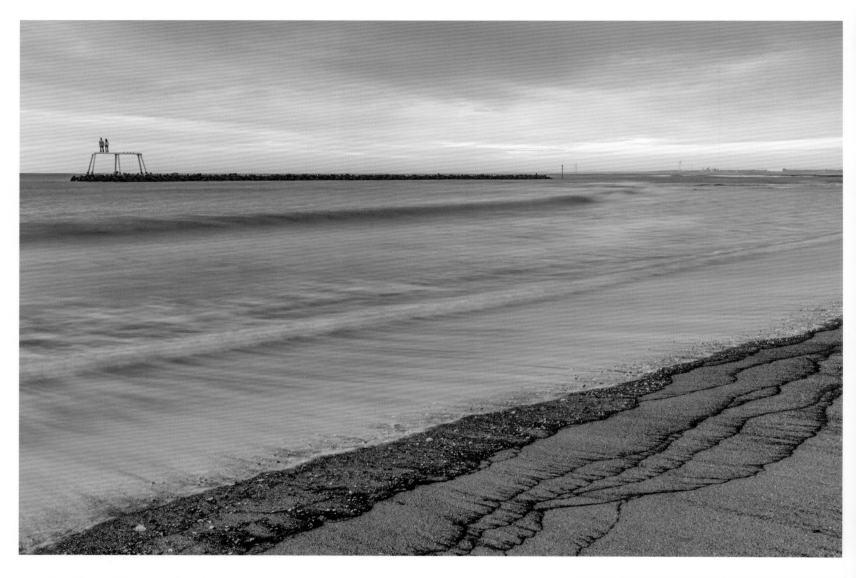

correctly, diffract). This means that the various rays of light that form the image travel different distances to reach the sensor, going out of phase with one another (and may even reinforce or cancel each other out). The practical effect is an overall softening or reduction in resolution.

To complicate matters, the pixel resolution of the sensor determines the aperture at which the effects of diffraction become noticeable. The higher the pixel resolution of a sensor (and the smaller the individual photosites on the sensor) the more diffraction-limited the sensor will be. This means that diffraction may be problematic at even relatively large apertures. For this reason, the lenses found on high-resolution compact cameras are often limited to a minimum aperture of f/8 or f/11.

HYPERFOCAL DISTANCE

One technique for maximizing depth of field is to focus at the hyperfocal distance. Depth of field will then extend from half the hyperfocal distance to infinity. The hyperfocal distance varies according to the aperture used, the focal length of the lens, and the sensor in the camera, so the most convenient way to calculate hyperfocal distance (taking into account these three variables) is to use a smartphone app such as PhotoPills or PhotoCalc.

Left: If you focus at Infinity (∞), much of the available depth of field at a given aperture is wasted. Using a technique such as the hyperfocal distance spreads depth of field more effectively through the image space. The hyperfocal distance for a 35mm lens set to f/16 on a full-frame camera is 2.6m/8.5ft. By focusing at that distance I was confident that the depth of field would extend from 1.3m/4.2ft to ∞ in this image.

Focal length: 35mm

Aperture: f/16

Shutter speed: 2 sec. (with 3-stop ND grad filter)

ISO: 100

REPRODUCTION SIZE

If you reduce an image so that it's a fraction of its original size, or view it from a significant distance, it will appear sharper. This shouldn't be an excuse for sloppy technique, but it does mean that images destined to be reproduced at a relatively small size (such as on a web site) don't need to be critically sharp, as shooting errors will be masked when the image is shrunk to its intended reproduction size. The same applies to other image blemishes, such as the appearance of noise.

Right: Achieving front-to-back sharpness isn't a requirement for every shot, even when shooting subjects such as landscapes. The key when shooting with a relatively large aperture is to focus precisely on the subject.

Focal length: 80mm

Aperture: f/2.8

Shutter speed: 1/640 sec. (with 2-stop ND grad filter)

ISO: 200

Reflectors & Diffusers

Reflectors are used to bounce light into areas of shadow in a scene, in order to reduce contrast to manageable levels. The most common style of reflector is a circular folding type made of cloth that can be anything from 12 inches to 6½ feet (30cm–2m) in diameter when opened up. Reflectors are typically used for relatively small subjects, such as people or still-life subjects; larger features, such as wide-open landscapes or architecture, aren't usually suitable.

Reflectors are available with different surfaces that affect the image. White reflectors are subtly reflective, while gold or silver reflectors are more efficiently reflective, but the light tends to be more hard and focused (and, in the case of gold reflectors, warmer too). As they are opaque, reflectors can also be used to shade small features from light, which is an alternative way of managing high contrast.

Diffusers are semi-translucent and are used to reduce contrast by shading the subject with the diffuser. The light that passes through the diffuser is softened so that highlights are less intense and shadow density is reduced.

Left: This carving was top lit and curved down so the underside was in shadow. Without intervention, the contrast range was uncomfortably high (far left). However, a reflector held below the carving let me direct light from underneath to increase the brightness of the shadows (left). The exposure was not changed between the two shots.

Focal length: 200mm

Aperture: f/3.5

Shutter speed: 1/5 sec.

ISO: 100

Above: A reflector that's sufficiently large can also be used to shade a subject from direct sunlight. This is an alternative (but equally effective) way of reducing contrast.

Focal length: 100mm

Aperture: f/4

Shutter speed: 1/400 sec.

ISO: 400

Macro

Macro photography is the technique of shooting subjects at a reproduction ratio greater than 1:1. This requires the use of accessories such as extension tubes or bellows, or, for better image quality, a dedicated macro lens. The basic concepts of exposure don't change when you shoot macro subjects, but there are pitfalls that you need to be aware of.

Depth Of Field

The lack of depth of field is a major obstacle when shooting macro images. Even when using the smallest apertures available, depth of field may be insufficient to ensure front-to-back sharpness through the image. This isn't a problem when shooting a flat, two-dimensional subject straight on, but if you shoot a three-dimensional subject, the lack of depth of field quickly becomes problematic; and the greater the magnification you work at, the worse the problem becomes.

One solution is to think carefully about where you focus, ensuring that the most important part of your subject is critically sharp. Live View, combined with manual focusing, makes this a far easier task than using an optical viewfinder and autofocus.

Another, more involved method, is known as focus stacking. The principle idea is that you shoot a sequence of photos of your subject, altering the focus point as you shoot. Typically, you would start by focusing at the front of the subject and gradually work your way backward, shifting the focus toward the rear of your subject. The sequence of shots is then blended using software such as Adobe Photoshop.

The drawback to this technique is that it only works if the camera and the subject remain still while you shoot the sequence. This makes it an easier technique to apply in a studio setting than when shooting natural subjects outdoors.

Left: Even with the aperture set at f/8 there is very little that is sharp in this shot of a fern head.

Focal length: 100mm

Aperture: f/8

Shutter speed: 1/250 sec.

ISO: 200

REPRODUCTION RATIO

A reproduction ratio describes the size of the image of the subject projected by a lens onto the digital sensor. A 1:1 reproduction ratio means that the projected image on the sensor is exactly the same size as the subject; a 1:2 reproduction ratio means that the projected image is twice the size as the subject (and so is more magnified); and so on.

Above: Focus stacking a series of macro images lets you achieve a depth of field that would otherwise be impossible. However, you need consistency in the exposure and to be sure that you make a sufficient number of exposures to avoid any soft areas in the final stacked image. Some lenses aren't suitable for focus stacking, especially lenses that "breathe" as you focus. Breathing is a term used to describe the way that a lens subtly changes its focal length as you focus.

Focal length: 70mm (with extension tubes)

Aperture: f/5.6

Shutter speed: 1/15 sec. (15 images)

ISO 100

Aperture

The more light you can use to illuminate your macro subject, the easier it will be to achieve pleasing results. This is partly because any movement of your camera during the exposure will be magnified, so the shutter speed should be as high as possible, particularly when shooting handheld (shooting with your camera mounted on a tripod is a better option, although this is sometimes not always possible if your subject is relatively inaccessible). It is also because the use of relatively small apertures runs the risk of diffraction (a good reason to consider focus stacking if this is practical).

Another factor that affects exposure when shooting macro is that the amount of light reaching the sensor diminishes the greater the magnification you use. Therefore the aperture you use should no longer be considered the actual aperture, but an "effective" aperture.

Different camera systems handle this change in different ways. Nikon, for example, adjusts the available aperture range the closer you focus, which means that the maximum aperture of the lens will appear to be smaller than when the lens is used more conventionally (so an f/2.8 macro lens may appear to have a maximum aperture of f/5.6 or smaller when at closest focus). However, Canon cameras do not adjust the available aperture range, so f/2.8 would still be the maximum aperture selectable on an f/2.8 macro lens.

Regardless of which camera system is used, as the lens is focused closer the shutter speed will need to increase, due to the reduction in the amount of light reaching the sensor. This change will be taken care of when using a camera's built-in metering system, but if you use a handheld light meter combined with Manual exposure you'll need to make the adjustment yourself when you set the exposure. This is achieved by increasing the shutter speed by the same factor as the difference between the metered aperture setting and the effective aperture.

First, you need to calculate the effective aperture by multiplying the metered aperture value by 1 plus the magnification factor:

effective aperture = [metered aperture value] x [1+magnification factor]

So, for example, if the metered exposure is f/11 at 1/60 sec. and you're shooting at a 1:1 reproduction ratio, the effective aperture will be f/22 (f/11 x 2).

This is a 2-stop difference, so while the aperture should be set to f/11 as originally metered, the shutter speed should be extended to 1/15 sec. (a 2-stop increase).

Left: Illumination is the key to shooting macro subjects, particularly those that are prone to movement. The interior of this poppy head was lit using two reflectors to bounce light inside. This allowed me to use a fast shutter speed and avoid blur.

Focal length: 100mm

Aperture: f/4.5

Shutter speed: 1/1000 sec.

ISO: 800

Video

It's easy to think that shooting a video is the same as shooting a still image, and in many ways the two are very similar: both require you to set the exposure, ideally so that no detail is lost in the image. However, the big difference between still images and video is that you shoot hundreds, even thousands of individual frames to produce a video sequence. This means that you have to plan the exposure more carefully, so it remains consistent throughout the shooting process. The longer a sequence, the more careful this planning needs to be; it's very distracting to watch video footage that constantly changes brightness over its duration.

Frame Rate

Video is shot at a particular frame rate, which is measured in frames per second (fps). The frame rate you choose depends on a number of factors. Movies shot on film typically use a frame rate of 24fps, but video footage designed for TV broadcast is shot at 25fps or 30fps in PAL or NTSC areas respectively (strictly speaking NTSC footage should be shot at 29.97fps, and some cameras offer this option).

Cameras often allow the use of higher frame rates (50fps or 60fps are common options). The drawback to shooting at a higher frame rate is that more video data needs to be captured and stored by the camera. To get around this problem manufacturers often restrict the resolution that

video is shot at when using higher frame rates. The use of a high frame rate gives you the option of slowing the footage down later, in postproduction, without the footage looking unnaturally jerky.

RESOLUTION

Video destined for broadcast HDTV should be shot using a 16:9 aspect ratio, with a resolution of 1920 x 1080 pixels. The latest trend is to shoot video footage using the 4K standard of 3840 x 2160 pixels. At the time of writing, there are relatively few cameras capable of shooting natively in 4K, and fewer televisions that are 4K compatible. However, 4K will become more common as time passes, so if your camera can shoot 4K, it's worth considering, as this will make your video footage more future-proof. Video shot for display on desktop PCs or the Internet is less restricted by resolution, although 4K footage places more stress on Internet bandwidth than lower resolution footage.

Shutter Speed

Each individual frame of video is exposed for a set period of time. If you think this sounds like shutter speed then you'd be right. In fact, you need to set all three exposure controls—shutter speed, aperture, and ISO—when shooting video, unless you are shooting in an automated exposure mode.

Of the three exposure controls, shutter speed arguably requires the most thought. The shutter speed should never be slower than the selected frame rate—do this and the resulting footage will appear smeared and soft. However, set the shutter speed too fast and the resulting footage can look overly crisp and staccato. This is fine for short, fast-action sequences, but the footage can be

tiring to watch for more than a few minutes. Ideally, the shutter speed should be twice the frame rate (so 1/60 sec. when shooting at 30fps, for example). This produces acceptably crisp footage with a slight blur that helps individual frames blend into each other, making the footage smoother and easier to watch comfortably.

Controlling the shutter speed when shooting video can often be more difficult than when shooting stills, particularly if you are shooting in bright ambient light. This is because there is a smaller range of useful shutter speeds to choose from (typically between 1/50 sec. and 1/250 sec. depending on the frame rate chosen). Therefore, one almost vital piece of equipment when shooting video is an ND filter. By using different strength ND filters it's generally possible to reduce the shutter speed to an acceptable value. Many videographers use variable ND filters, rather than standard ND filters, as this allows them to adjust the strength of filtration, saving the need to constantly swap filters if the ambient light level changes.

ZEBRAS

Many cameras can be set to display a zebra pattern on the rear LCD screen when shooting video. The zebra pattern shows where an image is close to being overexposed, or is actually overexposing. It's usually possible to set the level of overexposure at which zebras are displayed. This is done using the IRE scale, where black is 7.5 and white is 100 (skin tone normally falls within the range of 50–80 IREs).

Aperture

The aperture in the lens controls depth of field in exactly the same way as it does when shooting still images. Many videographers use APS-C and full-frame system cameras in preference to more traditional camcorders because it's easier to restrict depth of field with a system camera (camcorders typically have smaller sensors and lenses with smaller maximum apertures).

Shooting with a restricted depth of field produces cinematic-looking footage that is atmospheric and esthetically pleasing (although as with most techniques, it's not a good idea to use it exclusively). The difficulty in shooting this way is maintaining focus. If your subject moves then you'll need to constantly refocus the lens; footage may end up unusable if your subject moves in and out of focus in a random and distracting way.

Professional filmmakers work with actors to ensure that they move to pre-determined places during a scene. This means that focus distances can be calculated before shooting and quickly and smoothly "pulled" to the correct point on the lens when needed.

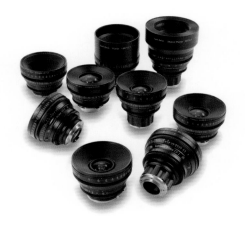

Above: Although any lens can be used to shoot video, greater control over focus and aperture is possible with dedicated cine lenses. This includes the setting of T-stops, as on these Zeiss cine lenses.
© Zeiss

T-STOPS

The aperture settings on most consumer camera lenses are not accurate enough for professional movie work. This is because the glass elements in a lens absorb some of the light that passes through the lens, which isn't taken into account by the lens' f-stop values. In practical terms, this means that at a particular aperture setting, one lens may let through a fractionally different amount of light compared to another lens set to the same aperture. Swap between those two lenses when shooting video footage and the exposure of the footage may be slightly different, making it harder to edit together in postproduction.

Because of this, lenses designed specifically for video work use T-stops rather than f-stops. T-stops are a measure of the amount of light transmitted through the lens at each aperture setting (calculated by dividing the aperture f-stop value by the percentage of light transmitted by the lens). This means that if you set two lenses to the same T-stop setting, you can be confident that exposure will not change if the lenses are swapped.

Profiles

Individual frames of video footage shot on a digital camera are effectively a sequence of JPEGs played in chronological order of shooting. Just like a JPEG, the footage is processed as it's written to a memory card, which includes applying the picture parameters set prior to shooting. So, just like a JPEG, it's important to think carefully about which picture parameters are most appropriate— make the wrong choice and it may be impossible to unpick that choice during postproduction (no consumer digital camera currently offers the equivalent of Raw when shooting video).

"Grading" is the term used to describe the adjustment of color and contrast of video footage in postproduction. It's always easier and more effective to add contrast or color saturation to video footage than remove it later. The same is true of lightening underexposed footage—noise will quickly show and is far more difficult to remove from video footage than from still images.

S-LOG

One welcome trend is the addition of flatter picture parameters to new video-enabled digital cameras. One standard that is slowly taking hold is S-log (or V-log). This effectively increases the dynamic range of video footage to enable detail to be retained in the highlight areas more easily. The resulting footage usually appears gray and washed out, but is very responsive to grading in postproduction.

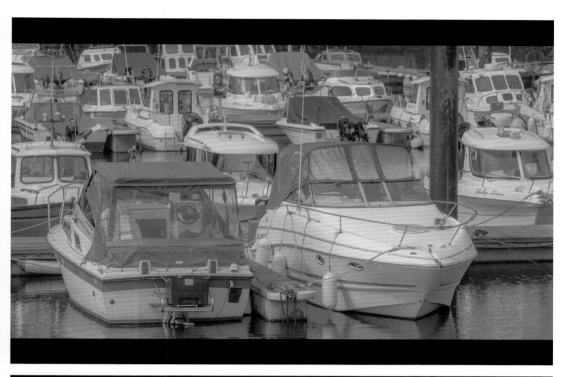

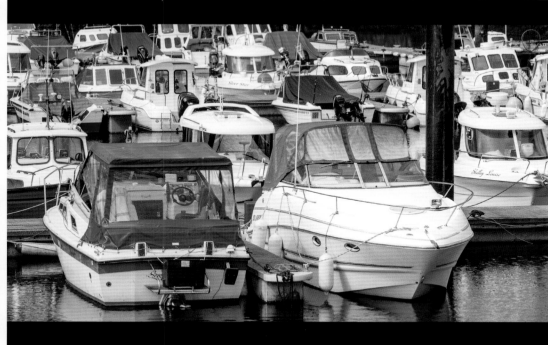

Left: Shooting video footage with a flat picture parameter (above left) allows greater scope for grading later in postproduction (left). The downside is that you are then committed to adjusting the footage; just like Raw, the footage is not immediately useful.

Chapter 6
Filtration

A filter modifies the light that passes through the lens to the sensor in a quantifiable way. Thanks to the power of image-editing software it's easy to believe that filters have had their day, but this is a fallacy. While some types of filter may be obsolete unless you shoot film (color-correction filters have been superseded by white balance, for example), the effects of some filters on exposure— ND filters and polarizers in particular—cannot be replicated easily, either in-camera or during postproduction. Other types of filter, such as graduated ND filters, help to cut down on the amount of postproduction that may be required later. If you're shooting hundreds of images a week this can save you a lot of time sat in front of your computer.

Right: Graduated ND filters are invaluable for landscape photographers. This image required the use of a 2-stop graduated ND filter to balance the exposure between the brightly lit top half of the shot and the darker, shadowed area below.

Focal length: 200mm

Aperture: f/11

Shutter speed: 1/800 sec. (with 2-stop graduated ND filter)

ISO: 200

Filter Types

Filters are sold in two different forms: they either fit directly onto the filter thread of a lens (screw-in filters) or slot into a filter holder that's attached to the lens (system filters). There's no right or wrong answer as to which is preferable, as both types have their advantages and disadvantages.

Circular, screw-in filters have the advantage of being relatively inexpensive and easy to find. The downside to this type of filter is that there is no standard filter thread size. With care it's possible to purchase different lenses that share a common thread size, but the more diverse your lens selection, the harder this becomes. If you own two lenses with different thread sizes then you either need to duplicate your filters or use stepping rings to adapt your filters to fit one or more of your lenses. Hoya and B+W are two respected manufacturers of circular screw-in filters.

System filters are square or rectangular, and are designed to fit into a filter holder. The advantage of a filter holder is that it can be made to fit onto any lens using a low-cost adaptor ring. The disadvantage to system filters is that they're invariably more expensive than screw-in filters—there's the cost of the holder to consider before you even think about buying your first filter. There are several manufacturers of filter holder systems: Cokin and Lee Filters are the most well known, with NiSi being a new entrant to the market.

Both Cokin and Lee produce multiple filter holder systems designed for specific camera types, and the smaller the holder system, the less expensive it will be. However, smaller holder systems can cause vignetting at the corners of images, particularly if a wide-angle lens is used. See the grid above for details.

FILTER SYSTEM	FILTER SIZE	RECOMMENDED CAMERA TYPE
Cokin A	67mm	Compact
Cokin P	84/85mm	Compact/Bridge/Mirrorless
Cokin Z-Pro	100mm	Mirrorless/DSLR
Cokin X-Pro	120mm	DSLR/Medium format
Lee Seven5	75mm	Compact/Bridge/Mirrorless
Lee 100mm	100mm	Mirrorless/DSLR
Lee SW150	150mm	Nikon/Canon wide-angle lenses with projecting front lens elements
NiSi	100mm	Mirrorless/DSLR

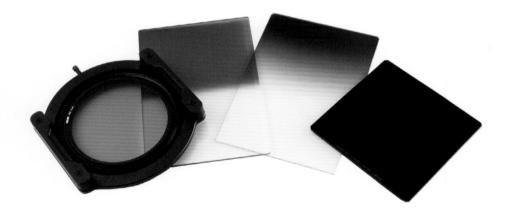

Above: An array of filters (from left to right): 100mm filter holder and polarizing filter; 3-stop hard graduated ND filter; 3-stop soft graduated ND filter; 10-stop ND filter.

Above: Some shots require multiple filters. To create this image I used a 6-stop neutral density (ND) filter to extend the shutter speed and blur the water on the foreshore. I also used a polarizing filter and 2-stop graduated ND filter to deepen the blue of the sky and to balance the exposure of the sky to the foreground. Stacking filters in this way will start to affect image quality, so the habit should be kept to a minimum.

Focal length: 20mm

Aperture: f/16

Shutter speed: 8 sec. (with 6-stop ND filter, 2-stop graduated ND filter, and polarizer)

ISO: 50 (Lo 1.0)

Filters & Exposure

The most common use for filters when shooting digitally is to adjust the exposure by reducing the amount of light reaching the sensor (see Neutral Density Filters on page 132). The less light that's transmitted by the filter, the more dense it is and therefore the greater the exposure adjustment required. However, it's not just filters specifically designed to adjust exposure that need to be taken account of. Even frequently used filters, such as polarizers, cause sufficient light loss to require an exposure adjustment.

Depending on the filter system you use, the degree of exposure adjustment needed is shown either as an f-stop adjustment or as a filter factor—you can convert between the two systems using the grid below. The density of a filter will be taken account of automatically when you are using your camera's built-in, through-the-lens metering, but if you use a handheld light meter the appropriate exposure adjustment will need to be made when setting the exposure.

FILTER EXPOSURE COMPENSATION TABLE			
FILTER TYPE	FILTER FACTOR	F-STOP ADJUSTMENT	LIGHT TRANSMISSION
Skylight/UV	1x	None	100%
Polarizer	4x	2 stops (approx.)	25%
ND 0.1	1.3x	⅓ stop	84%
ND 0.3 (ND 2)[1]	2x	1 stop	50%
ND 0.6 (ND 4)[1]	4x	2 stops	25%
ND 0.9 (ND 8)[1]	8x	3 stops	12.5%
ND 1.8 (ND 64)[1]	64x	6 stops	1.6%
ND 3.0 (ND 1024)[1]	1024x	10 stops	0.1%

[1] Lee Filters and Tiffen notation on the left; Cokin, Hoya, and B+W in parenthesis.

Above: Flowing water can be interpreted in a number of ways by using different shutter speed settings. Light-reducing filters allow you to finely control the shutter speed without the need to adjust the aperture setting any more than necessary.

Focal length: 200mm

Aperture: f/16

Shutter speed: 1 sec. (with 3-stop ND filter)

ISO: 100

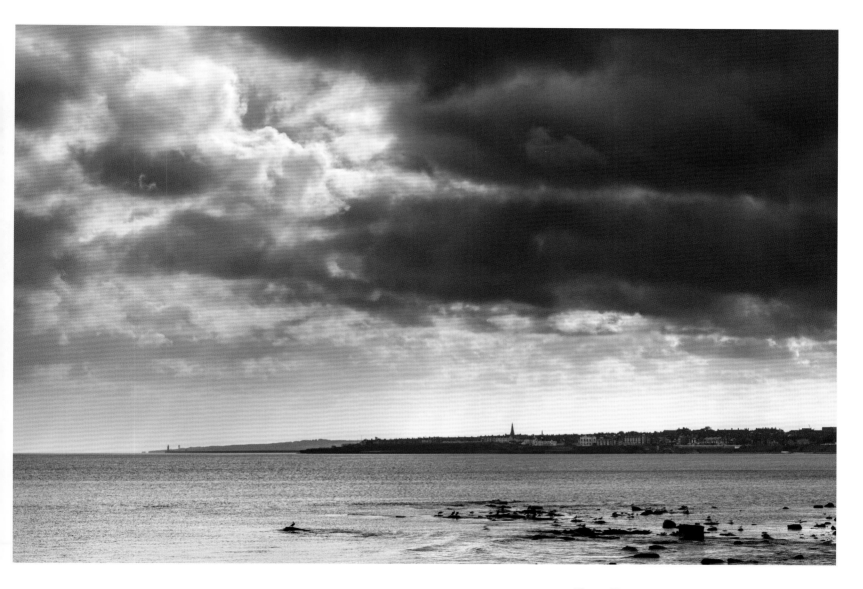

Above: There are two approaches to using filters. The first is to only use them to overcome the shortcomings of a camera in a particular lighting situation; the second is to use them to intentionally enhance or add to the impact of an image. This shot takes the second option, with a 3-stop graduated ND filter over-darkening the sky and giving it a moody, atmospheric feel.

Focal length: 80mm

Aperture: f/14

Shutter speed: 1/25 sec.

ISO: 100

Neutral Density Filters

It's not uncommon to find yourself in a situation where it's simply impossible to use a particular combination of shutter speed and aperture. In low light this can be remedied by increasing the ISO, which will let you set a faster shutter speed and/or smaller aperture than would otherwise be possible. However, in bright conditions there's often less room for maneuver: once you've set the lowest ISO possible you still might not be able to select as slow a shutter speed or as large an aperture as you'd like.

The solution to this problem is neutral density (ND) filters. ND filters are semi-opaque filters that are available in a range of different strengths; 1 stop, 2 stop, and so on. As ND filters are semi-opaque they reduce the amount of light reaching the sensor, with each stop of filtration equivalent to a halving of the ISO setting (so, if your camera's base ISO is 100, using a 1-stop ND filter would mimic an ISO 50 setting, a 2-stop filter is equivalent to using ISO 25, and so on).

COLOR CASTS

Neutral density refers to the fact that ND filters reduce the intensity of all wavelengths of visible light equally. This means there should be no color shift when an ND filter is used. However, low-cost ND filters often aren't strictly neutral and will cause a noticeable color tint or cast across the image. This can be cured by using your camera's auto white balance setting, or during postproduction, but for consistent color accuracy this is generally undesirable.

ND FILTER EXPOSURE COMPENSATION			
SHUTTER SPEED	1 STOP	2 STOP	3 STOP
1/8000	1/4000	1/2000	1/1000
1/4000	1/2000	1/1000	1/500
1/2000	1/1000	1/500	1/250
1/1000	1/500	1/250	1/125
1/500	1/250	1/125	1/60
1/250	1/125	1/60	1/30
1/125	1/60	1/30	1/15
1/60	1/30	1/15	1/8
1/30	1/15	1/8	1/4
1/15	1/8	1/4	1/2
1/8	1/4	1/2	1s
1/4	1/2	1s	2s
1/2	1s	2s	4s
1s	2s	4s	8s
2s	4s	8s	15s
4s	8s	15s	30s
8s	15s	30s	1m
15s	30s	1m	2m
30s	1m	2m	4m
1m	2m	4m	8m

Tip

When using an ND filter you should always select a fixed ISO value. If you use Auto ISO, the camera will increase the ISO value, negating the reason for using the ND filter.

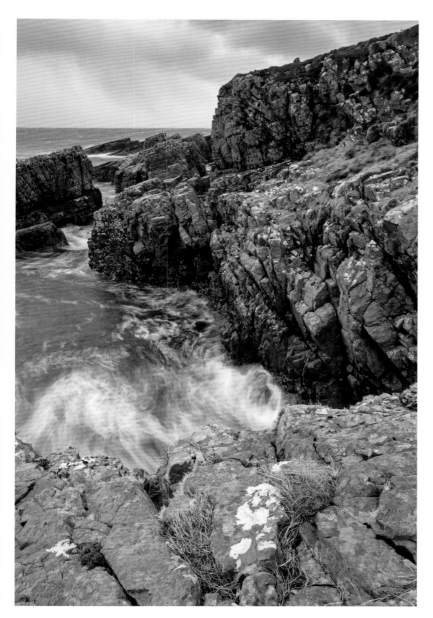

Above: Even on a dull, overcast day achieving the desired long shutter speed may not be possible. Using a 3-stop ND filter, as in this image, is effectively the same as setting the ISO 3-stops lower than the base ISO of the camera.

Focal length: 32mm

Aperture: f/16

Shutter speed: 1.6 sec. (with 3-stop ND filter)

ISO: 100

Above: Due to their slight opacity and 2-stop light loss, polarizing filters can also be used as ND filters. This shot was created by combining a polarizing filter with 2-stop and 3-stop ND filters.

Focal length: 55mm

Aperture: f/16

Shutter speed: 10 sec. (with 2-stop and 3-stop ND filters; polarizer)

ISO: 200

Extreme ND Filters

For some images, a 1-, 2-, or even 3-stop ND filter isn't enough. To meet this need, filter manufacturers introduced "extreme" ND filters that offer 6-, 8-, or even 10-stops of filtration. These very dense filters allow the use of long shutter speeds even when shooting in bright conditions (and avoid the need to stack multiple ND filters together and compromise image quality).

You can use the grid at the right to determine the difference between a shutter speed without a filter fitted and when a 6-, 8-, or 10-stop filter is used. Note that when a shutter speed longer than 30 seconds is required you'll need to use your camera's Bulb setting (see pages 76–77).

Unfortunately, there's a downside to using extreme ND filters. Despite the name, extremely dense ND filters often have a very strong color cast that will need to be corrected. This can be achieved in-camera using Auto White Balance (this is the recommended method when shooting JPEG), but it is far more effectively cured in postproduction when shooting Raw.

The simplest way to achieve accurate colors is to shoot a test image of a white balance target (or gray card). The target should be lit by the same light as your subject, and shot at the same exposure as the final photograph, with the ND filter in place.

Then, remove the target from the scene and take your "proper" exposure. Import both the test and final images into your postproduction software and use the software's white balance color picker tool to set the correct white balance by clicking on the target in the test image. Apply the same white balance setting to your final image.

EXTREME ND FILTER EXPOSURE COMPENSATION			
SHUTTER SPEED	6 STOP	8 STOP	10 STOP
1/8000	1/125	1/30	1/8
1/4000	1/60	1/15	1/4
1/2000	1/30	1/8	1/2
1/1000	1/15	1/4	1s
1/500	1/8	1/2	2s
1/250	1/4	1s	4s
1/125	1/2	2s	8s
1/60	1s	4s	15s
1/30	2s	8s	30s
1/15	4s	15s	1m
1/8	8s	30s	2m
1/4	15s	1m	4m
1/2	30s	2m	8m
1s	1m	4m	16m
2s	2m	8m	32m
4s	4m	16m	64m
8s	8m	32m	128m
15s	16m	64m	256m
30s	32m	128m	512m
1m	64m	256m	1024m

Tips

When you fit an extreme ND filter to a DSLR you're unlikely to be able to see through the viewfinder, so you'll need to frame your shot before fitting the filter. Depending on the ambient light levels a Live View display or electronic viewfinder may still be effective, although it will usually appear grainy.

AF systems are generally less effective (if they work at all) when an extreme ND is fitted. Focus before you fit the filter and then lock the focus. Switching to Manual focus is a very effective way of doing this, as long as you don't knock the focus ring when fitting the filter.

Cover the (optical) viewfinder of your camera during the exposure so that light doesn't leak into the camera and affect the image.

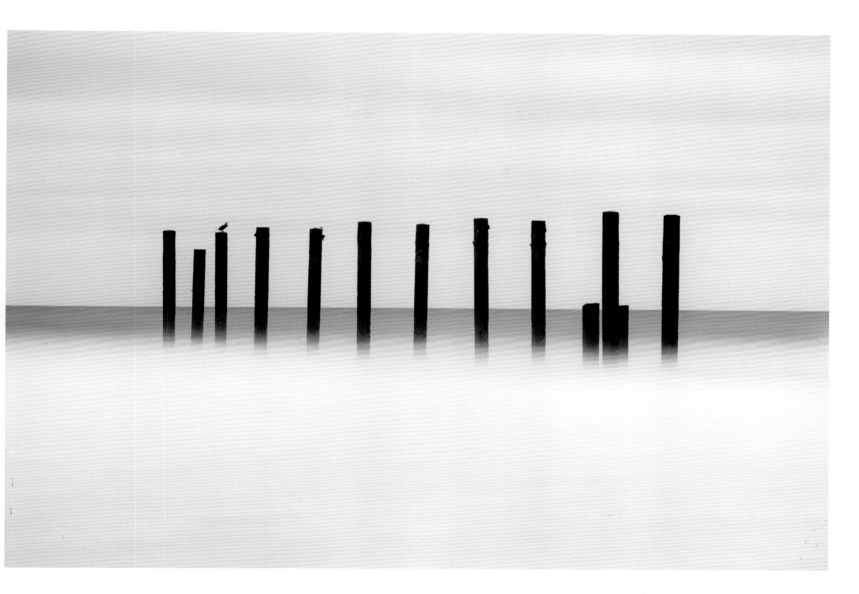

Above: One solution to the problem of an extreme ND filter's color cast is to shoot in black and white. This may seem like a restriction, but the effects of long exposures are often unnatural and minimalistic, an esthetic that's generally better suited to black and white than color.

Focal length: 60mm

Aperture: f/16

Shutter speed: 120 sec. (with 10-stop ND filter)

ISO: 100

Above: The white lighthouse in this scene was an ideal white balance target to help correct the color cast introduced by a 10-stop ND filter. The WB correction was significant—a scene like this would typically require a WB setting of 5500K (Daylight), but with the filter in place the WB required was 7900K.

Focal length: 32mm

Aperture: f/16

Shutter speed: 90 sec. (with 10-stop ND filter)

ISO: 100

Above: Backlit landscape scenes usually require the use of a graduated ND filter to hold detail in both the sky and the foreground. In this instance I used a 2-stop graduated ND filter to produce a naturalistic effect, matching how I saw the original scene. A stronger graduated ND filter would have darkened the sky further and added an unnecessarily dramatic and somber feel to the shot.

Focal length: 40mm

Aperture: f/13

Shutter speed: 1/45 sec.

ISO: 100

Graduated ND Filters

Graduated ND filters resemble regular ND filters, but with one important difference: the top half of the filter is semi-opaque, while the bottom half is completely clear. Graduated ND filters are used when there is a large difference in the brightness level of one half of a scene compared to the other. The most common users of graduated ND filters are landscape photographers, who often need to balance the exposure of a bright sky with a dark foreground. However, graduated ND filters can be used for other types of photography as well—portrait photographers occasionally use graduated ND filters turned on their side to balance the exposure of side-lighting, particularly from a source such as light shining through a window.

Just like ND filters, graduated ND filters are available in different densities (although there are no graduated ND filters available that match the strength of the extreme ND filters described on the previous page). The most common strength graduated ND filters are 1-, 2-, and 3-stop, but some filter manufacturers also produce 1½- and 2½-stop filters for more subtle exposure control. The greater the difference between the lighter and darker areas of a scene, the stronger the graduated ND filter required.

The key to using a graduated ND filter successfully is to shoot photos that look as though a filter has not been used. The transition zone between the semi-opaque and clear half of a graduated ND filter can be soft, hard, or very hard. Soft graduated ND filters reduce the risk that there will be an abrupt change in exposure down or across the image. They also make it less likely that elements of a scene that are jutting into the filtered area will be darkened unnaturally. However, the subtlety of soft ND filters often makes them difficult to place exactly.

Hard and very hard filters are the exact reverse: they're easy to place, but there is a risk that incorrect placement will result in oddly exposed areas above or below the transition zone.

Tips

Graduated ND filters don't need to be placed perfectly vertically or horizontally; rotate the filter for better coverage of the brighter areas of the scene if necessary. You do, however, have to place them accurately within the filter holder.

How high or low you place a graduated ND filter within the holder depends on where the transition between light and dark is within the scene. Place the filter too high and you'll create an overexposed strip across the scene. Place the filter too low and you'll create a dense strip across the darker area of your shot.

To help make the placement of the graduated ND filter easier, fit your strongest filter into the front rails of the filter holder and position it as required (assuming the correct exposure requires a weaker filter). Then, fit the required filter into the rear rails of the holder, in the exact same position as the first filter. Remove the first filter when you're ready to shoot.

Using Graduated ND Filters

The basic concept of using a graduated ND filter is that the exposure is set for the darker portion of a scene, without filtration: this exposure should not change once the graduated ND filter has been fitted. The exposure for the brighter area of the scene is then adjusted by the graduated ND filter—the strength of filter used determines how great this adjustment is. The choice of adjustment is yours and will depend on the relative exposure difference you want between the darker and brighter portions of the scene.

Deciding what strength graduated ND filter is required is far easier when a handheld spot meter is used. This allows you to compose your shot and then precisely measure the relative brightness of different areas within a scene without moving the camera. However, it's still possible to use your camera's exposure meter, as long as you take your exposure measurements before you compose. Use one of the following methods:

Metering method #1
(camera only)

1 Switch the camera to Manual exposure mode. Select center-weighted metering if available.

2 Point the camera at the darker portion of the scene and press halfway down on the shutter-release button to take a meter reading. Set both the aperture and shutter speed, so the darker portion of the scene is exposed correctly (take a test shot and review the image if necessary).

3 Aim the camera at the lighter portion of the scene. Press the shutter-release button down again to take another meter reading. Note the difference in stops, but don't alter the shutter speed or aperture settings. Use a graduated ND filter that reduces the difference to 1 stop (so, if the dark areas were 3-stops darker than the light areas, you should fit a 2-stop graduated ND filter).

4 Compose and shoot.

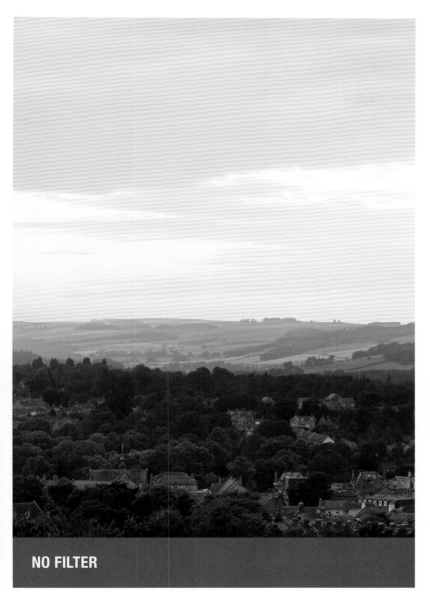

NO FILTER

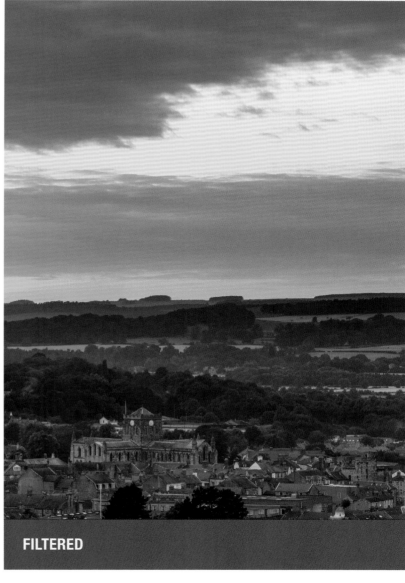

FILTERED

Metering method #2
(camera or handheld spot meter)

1 Switch the camera to Manual exposure mode. Select spot metering if you don't have a handheld spot meter.

2 Take a meter reading from a midtone area in the darker portion of the scene (in a landscape this would be the foreground). Set both the aperture and shutter speed according to this meter reading.

3 Take a meter reading from the brightest area of your scene (the sky, excluding the sun, when shooting landscapes). If the difference between the two readings is less than 2 stops, a graduated ND filter generally isn't necessary. When the difference is greater than 2 stops, fit a graduated ND filter with the strength to reduce the exposure of the brightest portion of the scene so it is approximately 1½-stops brighter than the darker portion.

Above: Graduated ND filters are almost a necessity when shooting landscape images. In this instance a 3-stop graduated ND filter was necessary to hold detail in the bright sunset sky. The exposure was set for the foreground, as I wanted detail there; if I'd exposed for the sky without filtration the foreground would have been too dark.

Focal length: 110mm

Aperture: f/11

Shutter speed: 1/2 sec. (with 3-stop graduate ND filter)

ISO: 100

Polarizing Filters

A polarizing filter—commonly referred to as a polarizer—performs two useful tasks when it comes to controlling exposure. The first is that it cuts out glare and reflections from non-metallic surfaces. The second is that it can be used to deepen the color of a blue sky, adding contrast and often helping to balance the exposure between the sky and the ground below.

However, there are limitations to when a polarizer can be used to achieve either effect. A polarizer will only cut out glare and reflections when used at approximately 35° to the surface of the subject—a polarizer can't be used to cut out reflections in glass when it's pointing directly at the glass, for example. When it comes to darkening a blue sky, the effect is strongest when the polarizer is used at 90° to the sun.

A more subtle and little-appreciated use for a polarizer is as an ND filter: polarizers are slightly opaque and block approximately 2- to 3-stops of light. For this reason it's not advisable to leave a polarizer permanently fixed to the front of a lens; there's no need to use a slower shutter speed, larger aperture, or higher ISO unnecessarily.

Polarizers are mounted in a metal ring that can be rotated through 360°. As you turn the ring the effect of the polarizer cycles from minimum to maximum and back to minimum again for every quarter turn of the ring.

CIRCULAR/LINEAR POLARIZERS
There are two types of polarizing filter currently manufactured: linear and circular. Neither name refers to the shape of the polarizer. Instead, it describes how a polarizer has been constructed and how light is affected as it passes through the filter. Although the effects are the same, linear polarizers are only suitable for use with manual focus lenses on a DSLR or on cameras that don't use phase detection auto focus. If you use a DLSR (or are thinking of buying one at some point) it is best to buy a circular polarizer.

Left: Polarizing filters can help to increase the apparent color saturation of slightly glossy subjects such as foliage. This is because the milky sheen on the surface of the subject is reduced.

Focal length: 26mm

Aperture: f/16

Shutter speed: 2 sec. (with polarizing filter)

ISO: 100

Above: Deepening a blue sky is a technique that's best employed when there is reasonable cloud cover. Polarizing clear blue can result in the sky looking "overcooked" and unnatural. Used well, polarizers can help add contrast to a sky and make clouds stand out from the background.

Focal length: 150mm

Aperture: f/13

Shutter speed: 1/125 sec. (with polarizing filter)

ISO: 400

Chapter 7

Flash

When extra light is needed, the humble flash is often the first choice for photographers. There are good reasons for this: there's usually a flash built-in to the camera, so there's no need for extra equipment; cameras often feature a hotshoe, so accessory flashes are easy to fit; flashes are relatively cheap compared to dedicated studio lighting (and also far more portable). For all these advantages, however, it takes time to learn how to make the most of flash. Flash also has its limitations, and these need to be understood in order to make progress. In this chapter, the ups and downs of using flash are explored.

HOTSHOE

A camera hotshoe is an electronic connection point for external flash units. The simplest hotshoe has one connection, which fires the flash when an exposure is made. However, camera manufacturers produce proprietary hotshoes with numerous unique connections. These are designed specifically for compatibility between the flash and that particular camera system, making it difficult to mix and match flashes between systems.

Right: Flash is a valuable tool when you require a fill-light to reduce contrast. Here, an off-camera flash was fired from the right to illuminate the statue.

Focal length: 28mm

Aperture: f/4

Shutter speed: 1/100 sec.

ISO: 100

Flash Overview

No matter how large or small, all flashes work on a similar principle. The light-emitting part of the flash is an airtight chamber filled with xenon gas. A power source (typically a set of batteries) charges up a capacitor within the flash, and when the flash is triggered, the capacitor discharges some or all of its stored electrical charge into the xenon-filled chamber. This charge excites the particles of gas so they release energy as a brief, but intense, burst of light. The capacitor is then recharged ready for the next shot. The time taken to recharge—known as the recycling time—lengthens the more depleted the batteries are.

Flash Power

The maximum intensity of the light emitted by a flash is ultimately governed by its power rating, known as the guide number. However, the power of a flash can be reduced automatically by the flash/camera combined (TTL flash) or manually. This is achieved by adjusting the length of time the flash emits light for. At full power, the burst of light emitted by a hotshoe flash typically lasts 1/800 sec. (and the capacitor is subsequently fully drained of power). As the power of the flash is reduced, the flash burst shortens in duration, so at ½ power, the flash of light lasts approximately 1/1600 sec. (and the capacitor is only drained of ½ its power); at ¼ power the duration lasts 1/3200 sec. (with only a ¼ of the capacitor's charge used); and so on.

In terms of exposure, this has several consequences. At lower power settings, less light is emitted by the flash, which means that the effective range is reduced. However, the flash duration is faster, so the flash can more readily "freeze" fast movement. It also has the benefit that recycling times are reduced, so during long exposures the flash can be triggered many times, rather than once.

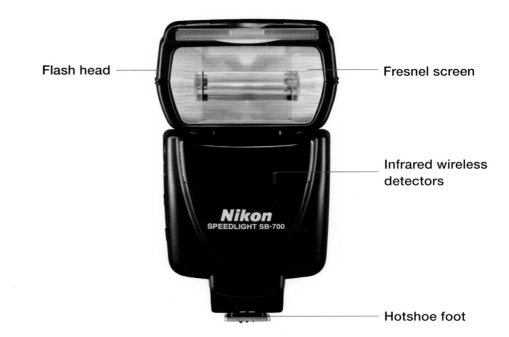

Flash head — Fresnel screen

Infrared wireless detectors

Hotshoe foot

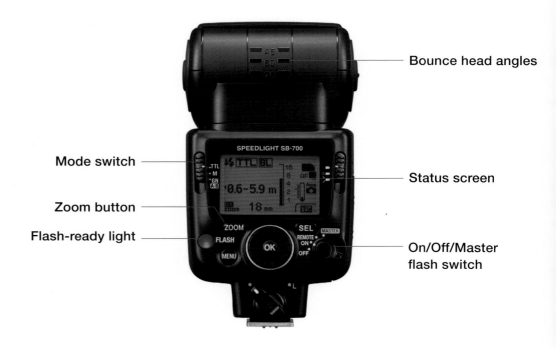

Bounce head angles

Mode switch — Status screen

Zoom button

Flash-ready light — On/Off/Master flash switch

Above: Using flash set to a low power means that the flash duration is shortened. This is ideal for freezing extremely fast movement. For this shot, the camera was set to fire continuously as water dripped into a tank. The light was supplied by two off-camera flashes, both set to $\frac{1}{32}$ power, connected wirelessly to the camera (see page 154), and positioned just inches from the water droplet area.

Focal length: 100mm

Aperture: f/16

Shutter speed: 1/250 sec.

ISO 100

TTL & Manual Flash

The first electronic flashes had little automation, so flash exposures were complicated and required patience to master. This changed when flashes with built-in light meters were developed, as the light meters could moderate the flash output based on the level of light reflected back from the scene. This was known simply as Auto flash.

Today, however, the most common flash control method uses TTL (through-the-lens) metering. This hands control of the flash exposure to the camera, rather than the flash. Each camera manufacturer has a proprietary TTL system, but the basic principle is that the flash is fired briefly before the shutter fires and this pre-flash is used to calculate the correct flash exposure. The shutter is then opened and the flash fired at the correct power for a successful exposure. This process happens so quickly that it's usually not possible to tell that two flashes of light were emitted.

The main problem with TTL flash systems is similar to that experienced when using evaluative metering: if the scene has a higher- or lower-than-average reflectivity, the flash exposure can be lower or higher than required. As with non-flash exposures, flash exposure can be adjusted using flash exposure compensation.

Right: An invaluable technique is using flash as a fill light to "lift" the darker areas of a scene, reducing contrast and balancing the exposure across the frame. Flash exposure compensation allows you to quickly adjust the flash output so that the required level of light reaches the shadows. In this shot, flash was used to throw light onto the statue and the tree above, both of which were far darker than the bright sky behind.

Focal length: 40mm

Aperture: f/5.6

Shutter speed: 1/200 sec.

ISO: 80

For more consistent flash exposures you can use manual flash. When setting your flash exposures manually you are in control of the power of the flash, so you set the power based on the intensity of light required. The power output can either by determined by shooting test shots or by using a flash meter. The flash exposure can also be adjusted by the altering the aperture and the camera's ISO setting. This doesn't change the intensity of the light emitted by the flash, but it does alter its effective range.

Guide Numbers

The guide number (GN) of a flash can be used to determine its maximum effective range at a particular aperture setting, or the aperture setting required to effectively illuminate a subject at a specified distance from the flash (this is not the camera-to-subject distance, unless the flash is either built into, or mounted on, the camera). As the GN varies at different ISO settings, flash manufacturers use ISO 100 as a standard to make comparisons between different models.

The formula *GN/aperture=distance* is used to calculate the effective flash distance when a particular aperture is set; *GN/distance=aperture* is used to work out the aperture required to light a subject at a known distance from the flash.

Inverse Square Law

Flash (and other point sources of light) obeys the inverse square law, as illustrated below. The idea is relatively simple: when an object is moved twice as far from a point light source it will receive ¼ of the level of illumination as it did previously.

Practically, this means you will need four times the amount of light for the object to receive the same level of illumination. This can either be done by quadrupling the power of the flash or by opening the aperture by 2 stops.

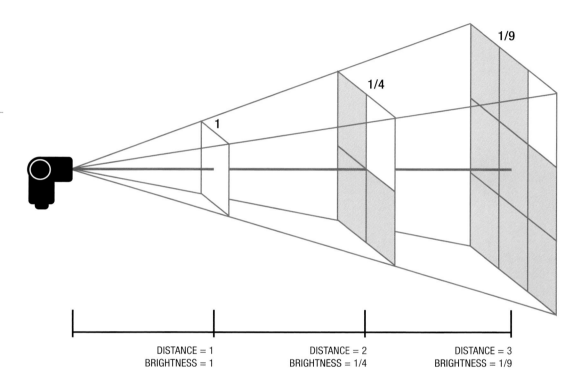

DISTANCE = 1
BRIGHTNESS = 1

DISTANCE = 2
BRIGHTNESS = 1/4

DISTANCE = 3
BRIGHTNESS = 1/9

GN AND ISO
Doubling the ISO does not double the GN as you'd expect. Instead, doubling the ISO increases a flash's GN by 1.4x—it's only when the ISO is quadrupled that the GN is doubled.

FLASH METERING
Handheld light meters can be used to determine the aperture needed to expose a flash-lit subject successfully. If you need to use a specific aperture, a handheld meter can also tell you how the power of the flash needs to be adjusted to achieve a correct exposure at that aperture. Note that the shutter speed is essentially irrelevant unless you are using slow-sync flash; typically it would be set to the camera's sync speed or just below.

There are two main methods of metering flash with a handheld light meter. Either the meter is connected to the flash via a sync cable, or the meter is set to flash mode and waits for the flash to fire. In both cases the meter reading is taken at the moment the flash fires.

Synchronization

A flash has to be able to work in synchronization with a camera and fire at the appropriate moment during an exposure. This technical requirement has certain ramifications for flash exposures.

Sync Speed

When shooting with a focal plane shutter camera (such as a DSLR or mirrorless camera), the fastest shutter speed available when using flash is known as the sync speed. There is no standard sync speed—this varies between camera models—but it is usually between 1/125 sec. and 1/250 sec. When a flash is attached and activated you will either not be allowed to set a faster shutter speed than this, or the camera will not fire if you exceed the sync speed.

When you're shooting in low light (which is often the reason for using flash to start with) a relatively slow sync speed isn't too great a restriction. However, when you want to use flash as a fill light—and the ambient light level is high—the sync speed can become problematic.

SHUTTER SPEED
A camera's shutter speed has no effect on flash exposure—the selected shutter speed only affects areas of a scene *not* lit by the flash.

LEAF SHUTTER
Leaf shutters are built into the lens, rather than the camera. When using a leaf shutter flash can be used at any available shutter speed.

Above: The short duration of light from a flash can be used to freeze movement. When slow sync flash is used, any movement before or after the flash fires (depending on how curtain sync is set) will be recorded as a blur.
Focal length: 46mm
Aperture: f/8
Shutter speed: 1 sec.
ISO: 80

Left: If the camera's sync speed is exceeded, the sensor will only be partially illuminated during the exposure. This is easy to do when using a sync cable to fire flash, as the flash will fire regardless of the shutter speed selected.
Focal length: 70mm
Aperture: f/7.1
Shutter speed: 1/500 sec.
ISO: 100

High-Speed Sync

One fundamental problem with flash is that it can only be used at the camera's sync speed or slower (usually 1/125–1/250 sec.). The sync speed is the fastest shutter speed at which the entire sensor is exposed to light. Above the sync speed the two shutter curtains create a slit that travels across the sensor during the exposure, so only the area of the sensor visible in this slit would be illuminated by the flash. The result is uneven illumination across the image space, as shown opposite.

Generally, the sync speed isn't an issue; flash is often used to add light into a scene when the ambient light level is low and the shutter speed is relatively lengthy. However, flash is also useful as a fill light when contrast is high, and in this situation it's all too easy to need a fast shutter speed to avoid overexposure.

The elegant solution devised by camera manufacturers is high-speed sync. This is a flash mode that effectively turns the flash into a constant light source by firing it rapidly and repeatedly during the exposure. The downside is that this pulsing of the flash reduces its effective range (by approximately 1 stop), so more attention needs to be paid to the flash-to-subject distance than when using "standard" flash modes.

1st & 2nd Curtain Sync

A focal-plane shutter has two light-tight "curtains," one in front of the other. When the shutter fires, the 1st (or front) curtain rises to start the exposure. The 2nd curtain starts to rise after the time specified by the shutter speed (so 1/125 sec. after the 1st curtain if the shutter speed is 1/125 sec.).

The camera can either trigger the flash when the 1st curtain begins to rise ("1st curtain sync") or when the 2nd curtain starts to rise ("2nd curtain sync"). When shooting a static subject, there is little difference visually between the two modes, but if you shoot a subject moving across the image space you will get a significantly different result, depending on the mode you choose.

When 1st curtain sync is selected, any movement is recorded as a trail in front of the subject; when 2nd curtain sync is used, the subject's movement is recorded as a blur behind the subject. Of the two available settings, 2nd curtain sync appears more natural, but some flash techniques—such as high-speed sync—are only available when 1st curtain sync is selected.

Above: Using slow-sync flash in low light, such as at dusk, is an effective way to ensure an entire scene is illuminated. The shutter speed will be slow, so it's a technique that's more successful when the camera is mounted on a tripod.

Focal length: 22mm

Aperture: f/11

Shutter speed: 1/60 sec.

ISO 100

Slow-Sync Flash

The limited range of flash means that often it is only the subject that is illuminated by flash; anything outside the range of the flash will only be lit by ambient light. Slow-sync flash is the technique of setting the shutter speed so the background (the area not lit by flash) is exposed correctly. This is invaluable when the ambient light level is low, but still high enough to illuminate the background effectively. Dusk, when there is still light in sky, is a particularly good time for using slow-sync flash. The procedure for setting slow-sync flash is camera-specific, but many will set slow-sync flash by default.

Tips

High-speed sync can't be used in conjunction with 2nd curtain sync.

High-speed sync is less effective at "freezing" movement, as the flash duration is longer than it is in "standard" flash modes.

Lighting Ratios

1:1 RATIO

3:1 RATIO

5:1 RATIO

9:1 RATIO

A lighting ratio specifies the difference between a meter reading of the direct illumination on a subject compared to a meter reading from the shadows. Lighting ratios apply to flash (and studio lighting) when there are two sources of illumination. The main, or brightest, light is the "key light," and the secondary light is the "fill light." The level of contrast is adjusted by changing the relative brightness of the two lights: in the case of flash this is achieved by adjusting the power output of the two flashes.

A lighting ratio of 3:1 shows that the more brightly lit areas of the subject are only 1-stop brighter than the shadows. This would produce a low-contrast effect. A more typical lighting ratio, which helps to deepen shadows and increase contrast, is a 5:1 lighting ratio, or a 2-stop difference in relative brightness. When the lighting ratio is above 6:1, the image will be high in contrast; lighting ratios higher than 9:1 (a 3-stop difference) are rarely used.

LIGHTING RATIO	FILL LIGHT FLASH POWER (WITH KEY LIGHT FLASH AT FULL POWER)	DIFFERENCE IN STOPS
1.2:1	–	¼
2.5:1	–	½
3:1	½	1
3:8.1	–	1½
5:1	¼	2
6.7:1	–	2½
9:1	⅛	3

Light Modifiers

Flash is a relatively hard light source, unless it is used extremely close to the subject. The light can also be wide and indiscriminate, falling on areas of a scene that need to remain unlit. Fortunately, a number of techniques and accessories can be used to modify the light from a flash.

Bounce

Above: The most useful flashes offer a wide range of tilt on the flash head, as well the ability to pan the head too.

Apart from the simplest models, external flashes often let you angle the head to control the light direction. This allows you to use a technique called bounce flash, which softens the light. The basic idea is that the light from the flash is "bounced" off a reflective surface near the subject, rather than lighting it directly. This surface could be a sheet of card, a commercial reflector, or a wall or ceiling, but should be neutral in color, as a colored surface will add a tint to the reflected light.

Because the flash-to-subject distance is increased when you bounce the light, you need to take this into account when calculating your exposure. If you're using TTL flash metering this will be compensated for automatically.

Diffusers

Above: Softboxes are available in a variety of sizes. The larger the diffuser, the softer the light from the flash.

A diffuser is a translucent surface through which the flash is directed, spreading and softening the light. Simple diffusers made of white plastic fit directly onto the flash head, and these are available for built-in flashes and external flash units. Larger box diffusers ("softboxes") and white, "shoot-through" umbrellas are only suitable for external flashes, as they typically require the use of a stand, with the flash connected to the camera either by a cord or wirelessly (see page 154). Softboxes tend to produce a more directional light than umbrellas, making it easier to adjust how the light falls onto your subject.

Regardless of the diffuser you use, there is always some light loss, so unless you are relying on TTL flash metering you will need to take a test shot or use a handheld flash meter.

Reflectors

Above: Reflective umbrellas usually have either a white or silver inner surface, although gold is also available.
© Lastolite

A reflector acts in a similar way to a diffuser, in that it spreads and softens the light from the flash. However, rather than direct the light from the flash through a translucent surface, it is bounced off a reflective surface.

Flash reflectors typically take the form of an expandable umbrella (as shown above) with a white or metallic inner surface—the light spread from a reflective umbrella is wider than a softbox diffuser or shoot-through umbrella.

Other Accessories

Various other accessories will help you direct light when using flash. The simplest method is to add baffles around the flash, such as barn doors. These are moveable flaps around the flash that can be positioned to direct where the light falls.

Other accessories include snoots, which are tubes that let you direct light precisely onto a chosen spot, and gobos, which is any object that can "go between" the flash and the subject to control the shape of the light.

Above: Bouncing light from a flash is a simple way to improve the quality of light that illuminates the subject. This image was shot with direct flash, which created hard, dense shadows behind the sheep.

Above: This image was shot with the light from the flash bounced off a neutral white reflector held above the sheep. As the light from the flash had to travel further, the flash power was increased by 2 stops to maintain the same level of exposure overall.

Focal length: 100mm

Aperture: f/11

Shutter speed: 1/125 sec.

ISO: 100

ZOOM

The light from an external flash can be modified by altering the zoom setting on the flash. Generally this should be set to match (as close as possible) the focal length of the lens you use. However, it's also possible to alter the zoom setting for creative effect. The higher the zoom setting, the more focused the light from the flash will be. This can be used produce a harder, spotlit effect than when the zoom setting is at its lowest value.

Left: Like any light source, the angle of the light from the flash relative to the subject is important. This is one reason why using off-camera flash is preferable to leaving the flash on the camera. Being able to the move the flash around gives you greater control over where highlights and shadows fall. For this shot, I placed the flash to the right of my subject to create stark, high-contrast side lighting.

Focal length: 185mm

Aperture: f/4

Shutter speed: 1/250 sec.

ISO: 100

Off-Camera Flash

A camera's built-in flash has severe limitations for creative photography. Not only is a built-in flash relatively low in power, but it's a frontal light that is less than ideal esthetically. The latter is also true of an external flash fitted to a camera's hotshoe, although the head of an external flash can often be angled to use the "bounce" technique.

Ultimately, the greatest control over light from a flash is achieved when it is used off-camera and fired wirelessly (flashes can connect to a camera via a sync cable, but these tend to restrict where the flash can be placed).

Flashes used off-camera can be triggered wirelessly using one of two methods: by light from the built-in flash, or a radio transmitter fitted to the camera's hotshoe.

Flash triggering is the cheapest option—you only need a compatible external flash—and it often allows you to use TTL metering as well. This reduces the need to use an external flash meter to determine your exposures. The downside is that the built-in and external flashes must be able to "see" each other, which makes it difficult to hide the external flash behind opaque parts of a scene.

Radio triggering is more expensive and complex, as you need flashes and radio triggers (one trigger each for your camera and flash). Flash exposure generally needs to be set manually, which either means using the equation on page 147 or setting your exposure using a flash meter. The benefit is that the range of a radio trigger is greater than a flash trigger, and line of sight does not need to be maintained.

In both cases, there are several points to remember when using off-camera flash. The first is that the flash-to-subject distance, rather than the camera-to-subject distance determines the flash exposure. Also, light from a flash can be hard, so it often needs softening with a diffuser or umbrella, or bringing close to the subject.

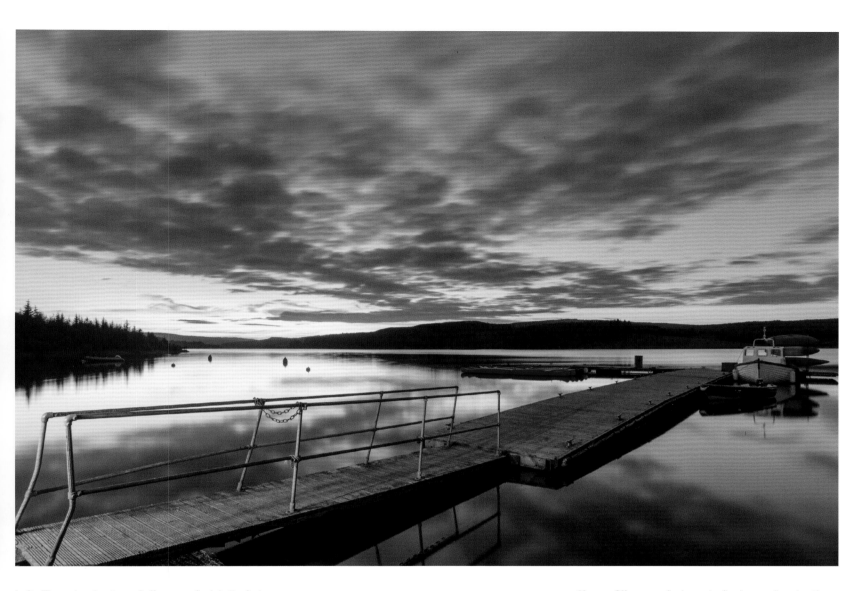

Left: The main advantage of off-camera flash is the fact that you have greater control of light direction. This statue benefited from side lighting to reveal its texture.

Focal length: 32mm

Aperture: f/11

Shutter speed: 1/80 sec.

ISO: 100

Above: Off-camera flash can be fired manually using the test fire button. This technique needs the shutter speed to be sufficiently lengthy so that you have time to fire the flash. The exposure for this shot was 15 seconds, which gave me time to fire the flash approximately 10 times off-camera onto the foreground jetty and across to the boat in the background. I set the flash power to ½ so it would recycle more quickly and give me time to modify the direction I pointed it.

Focal length: 20mm

Aperture: f/13

Shutter speed: 15 sec.

ISO: 100

Chapter 8
Postproduction

Ideally, an image should be as close to "perfect" as possible at the time of shooting. However, shoot Raw and some postproduction work will be needed to finish an image. This can range from simple adjustments—such as altering contrast—to wholesale revision of the image by switching from color to black and white. Postproduction work will also be required if you are shooting to achieve a particular result, such as blending a sequence of images to increase the dynamic range. The key is not to go too far, though. Postproduction is a process of slowly removing information from an image—push the adjustments beyond a certain limit and image quality will invariably suffer.

Right: When you shoot Raw, the functions set at the time of shooting—such as monochrome—can be unpicked and revised. There is a far greater range of image adjustments available, making postproduction a more satisfyingly creative way to produce a finished image, even though it requires time and effort after shooting.

Focal length: 20mm
Aperture: f/13
Shutter speed: 4.3 sec.
ISO: 200

Postproduction Fundamentals

There is much that can be done in postproduction to polish and finish an image. Some of these techniques—such as removing unwanted elements by cloning—are outside the scope of this book, but there are certain fundamental techniques that can be used to tweak an image's exposure. Understanding and applying these is an important step in mastering exposure.

Raw Converters

The first decision that needs to be made before tackling postproduction is deciding which software to use. This is very much a personal preference, but most software developers offer trial versions of their products, so you can get a feel for whether the software will suit your needs.

However, before clicking on a download button it's worth taking a look at the software that came with your camera. Generally, this software is less well regarded than other third-party offerings, but as it's essentially free, it's at least worth looking at.

The most well-known image-editing software is Adobe Photoshop, which celebrated 25 years of continuous development in 2015. Yet while Photoshop is undeniably powerful, it has lots of options that don't necessarily apply to photographers. As such, Adobe Lightroom is arguably more relevant, as it was designed from the outset to match the needs of photographers. Both Photoshop and Lightroom are now available on a subscription basis through a monthly fee.

Just because Photoshop and Lightroom are the most popular choices for postproduction software, that doesn't mean they're the only options. Other software worth exploring includes the highly regarded Capture One Pro 7 (produced by Phase One), DxO Optics Pro (by DxO), and Picture Code's PhotoNinja software. Each of these is a pro-spec tool that can be used to polish your images to a fine shine.

Above: Adobe Lightroom combines image editing and DAM tools, and is aimed specifically at photographers. This makes it a popular postproduction application.

DAM

Working on one shot is easy, but managing and working on multiple images is more difficult. This is when the concept of Digital Asset Management (DAM) becomes important. Software that has DAM capability will let you manage hundreds—even thousands—of images in a time-efficient way.

Adobe Photoshop doesn't have any DAM features, but Lightroom does. DAM lets you organize your images by both filename and folder; allows the addition of keywords and descriptions to the image metadata to enable efficient searching; and in postproduction it allows you to apply image adjustments to multiple images, reducing the amount of time needed to process those images.

Right: The two most basic adjustments that can be made to an image in postproduction are Contrast and Exposure (or Brightness). As demonstrated, these two tools can make a significant difference to a photograph. The adjustments to this image were made using Adobe Lightroom's Contrast and Exposure sliders.

Focal length: 55mm

Aperture: f/4

Shutter speed: 1/10 sec.

ISO: 1000

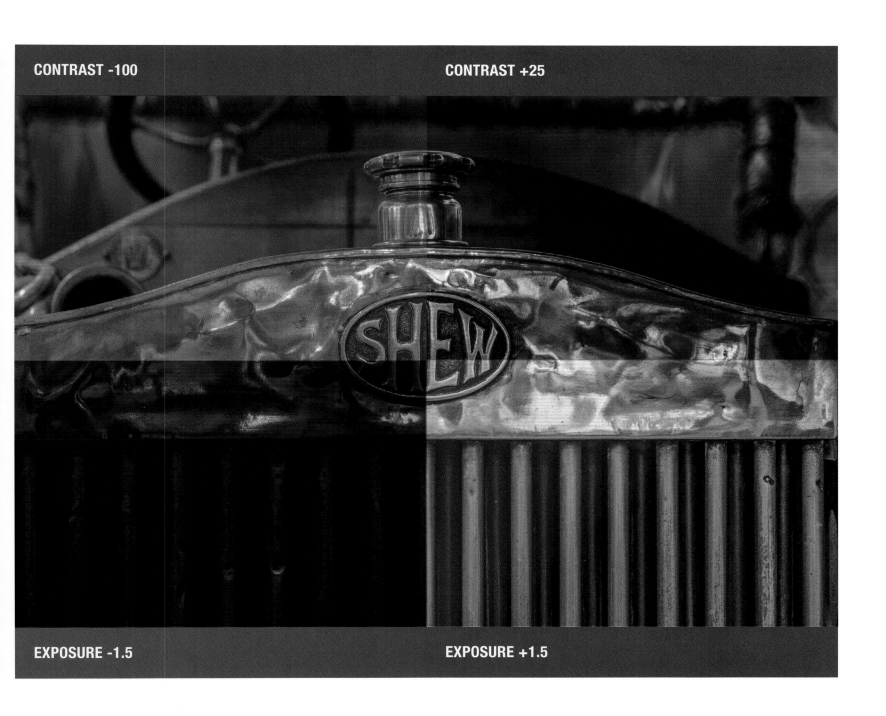

CONTRAST -100

CONTRAST +25

EXPOSURE -1.5

EXPOSURE +1.5

First Steps

The first postproduction task is to import your images from your camera's memory card to your computer's hard drive. Once this is done, it's a good idea to copy these images to either a CD/DVD or external hard drive. You can never have too many back-ups of your files—not only do hard drives fail, but files can be accidentally deleted or overwritten, potentially resulting in them being lost.

DAM-capable software will help automate the process of importing your images, and will also help you with the next postproduction task: sorting through and editing out the weakest shots.

There are many reasons why an image fails to make the grade, but in terms of exposure, there are three categories. The first category is images that require nothing more than a quick polish to be considered finished.

Images that fall into the second category are those that require more extensive work. This includes shots that you want to alter in a significant way, such as convert to black and white, or those where you've used the ETTR technique. This category also includes images with exposure errors that can be fixed without a significant compromise in image quality.

The final category is images that are beyond repair. These are images where the highlights are grossly clipped, or those that are so underexposed that adjustment is impossible without an unacceptable loss of quality. These are images that should be deleted (although only after an honest appraisal).

Local or Global?

There are basically two ways to apply adjustments to a photograph: locally or globally. A local adjustment is one that is made to a defined area of a picture, while a global adjustment is applied to an image in its entirety.

Generally, global adjustments should be applied first, which includes changes to the white balance and exposure correction. Once the image as a whole has been modified, local adjustments can be made to polish any rough edges. This can include lightening specific shadow areas (dodging), dulling down distracting bright highlights (burning), and cloning out blemishes, such as dust spots.

How far you process an photograph is largely a matter of taste, but the more an image is adjusted, the greater the loss of information (and quality). This loss will happen more quickly when processing JPEGs than Raw, but even Raw files can only be stretched so far before image quality deteriorates. Working on an image as little as possible has much to recommend it.

Below: Good DAM software should have tools that let you sort your images into logical groups. The two simplest tools are rating an image using one to five (or no) stars, or applying a color label. Both tools can be used to weed out images that have failed technically or esthetically, but they can also be used to sort images into groups that will have identical post-production techniques applied (separating images that will be converted to black and white from those that will remain in color, for example).

Above: There's a definite order in which to work on an image in postproduction. Like most of the photographs I work on, this was imported and global adjustments were made first. These included shifting the white balance to correct a slight magenta color cast; adjusting the contrast to separate the shadow and highlight tones; and boosting color saturation. Local adjustments were, in this instance, restricted to dust spotting and cloning out distracting details (such as a car on the road close to the buildings).

Focal length: 100mm

Aperture: f/11

Shutter speed: 1/90 sec.

ISO: 200

Adjustments

Although the names may be different, certain exposure-adjustment tools are common to virtually all well-specified image-editing programs.

Brightness/Contrast

This is the simplest exposure adjustment tool of all. Both the brightness and contrast of an image can be increased or decreased by moving a slider to a positive or negative value respectively. In most instances it's a fairly crude tool, so not recommended for anything other than very quick or minor adjustments.

Highlights/Shadows

Raw files generally allow significant adjustment to both the darkest and lightest areas of an image. Highlights/Shadows adjustment tools allow you to alter these areas of the tonal range without changing the brightness of midtone areas. As with most postproduction tools, relatively minor adjustment is generally better than major adjustment; if you lighten the shadows and darken the highlights too far an image will lose contrast and appear unnatural.

Exposure

The Exposure tool works in a similar way to a camera's exposure compensation function: exposure can be increased or decreased by fractions of a stop, or in full-stop increments. This means that exposure errors can be adjusted quickly and easily after shooting, although when lightening an image noise will quickly become more visible in the shadows.

Noise Reduction

When you shoot at your camera's base ISO, image noise should not be an issue if the exposure is "correct." However, shoot at high ISO settings, use long exposures, or push the image during postproduction and noise may become visible to a greater or lesser degree.

Reducing noise in postproduction is a balance between removing noise and retaining fine detail. Generally, both luminance and chroma noise can be removed or reduced, usually separately. Of the two, chroma noise is the least esthetically pleasing, so should be tackled first.

If noise reduction can be applied locally, consider only reducing noise in those areas that are lacking in fine detail (such as sky) and leave more textured, finely detailed areas alone.

Levels

The Levels tool allows you to adjust the tonal range of an image, either by compressing or expanding the tonal range. This is done by moving control points mapped to the black point, white point, and midtones (gamma). Pulling the black and white points closer together increases contrast. Moving the midtone control point to the left (toward the black point) lightens the image; moving it to the right (toward the white point) darkens it.

POSTERIZATION
Raw files are generally robust and can take a lot of tonal adjustment. However, there are limits. When an image has been processed too far it can become "posterized." This is seen as blocky or hard transitions in what should be a smooth range of tones.

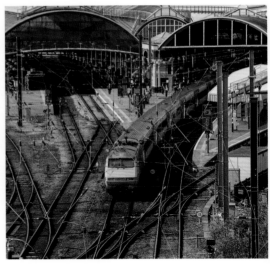

Above: Lightening an image after shooting is known as "pushing" the exposure, while darkening an image is referred to as "pulling" it. These terms derive from film photography where contracting or extending the length of time a film was developed for could adjust exposure to a limited degree. This was typically done when a film was either deliberately or accidentally under- or overexposed.

Focal length: 200mm

Aperture: f/8

Shutter speed: 1/400 sec.

ISO: 200

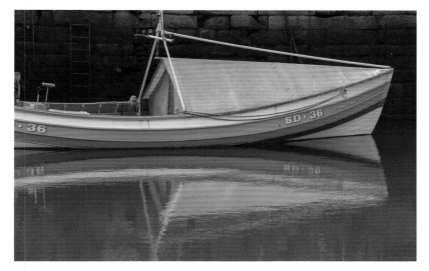
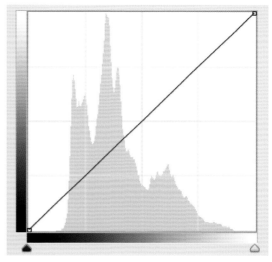

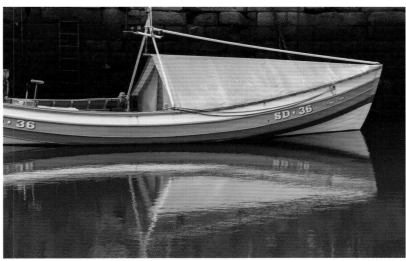
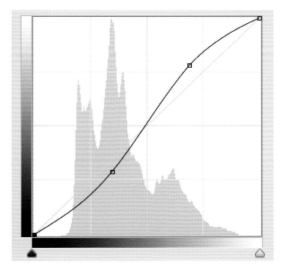

Curves

The Curves tool allows you to adjust specific parts of an image's tonal range. Tonal adjustments are made by adding control points to the curve (which, despite its name, starts as a straight line). When the control points in the curve are moved up and down, the input tones (shown as a gradient strip from black through to white along the horizontal axis of the curve) are mapped to the output tones (shown as a gradient strip from black through to white along the vertical axis of the curve).

WHITE/BLACK POINT

The black and white points in an image are the areas or pixels in the image that are pure black and pure white respectively. Both the Levels and Curves tools enable you to set the desired black and white points.

Above: The most useful type of curve is a contrast-boosting "S-curve." Pulling an upper control point upward lightens highlight areas (without changing the white point), while pulling a lower control point downward intensifies darker tones (without affecting the black point). This adds contrast to an image; contrast can be reduced by reversing the shape of the S-curve.

HDR

High Dynamic Range (HDR) photography is used in situations where the dynamic range of a scene is greater than can be captured by the camera (see pages 56–57). To create an HDR image, two or more shots of the same scene need to be captured using different exposure settings. A simple HDR sequence would involve shooting at the "correct" exposure followed by two more shots—one with negative compensation (to hold highlight detail) and a second with positive compensation (to reveal detail in the shadow areas). This three-shot sequence would typically be shot using automatic exposure bracketing to automate the exposure changes, with the degree of exposure alteration determined by the dynamic range of the scene: the greater the difference between the shadow and highlight brightness, the greater the exposure alteration required.

HDR imagery is either created in-camera when an HDR option is available or, more often, during postproduction. The latter option gives you more control over the process, including more choice in how the image will ultimately look.

During the postproduction process the sequence of images is combined by the HDR software. However, a raw 32-bit HDR image is relatively useless—it cannot be displayed accurately on a computer monitor (or in print), as the tonal range is too great. It also can't be used for more general purposes. Therefore, the second stage of creating an HDR image involves compressing the tonal range of the image so it can be saved as either an 8-bit JPEG or an 8-bit or 16-bit TIFF.

This process is known as tone mapping, and there are many ways that an HDR image can be tone mapped. Some are realistic (or as realistic as a photograph can be), while others produce alarmingly unnatural, or "hyper-real" results. However, much of this is subjective and HDR is arguably more open to personal interpretation than "conventional" color photography.

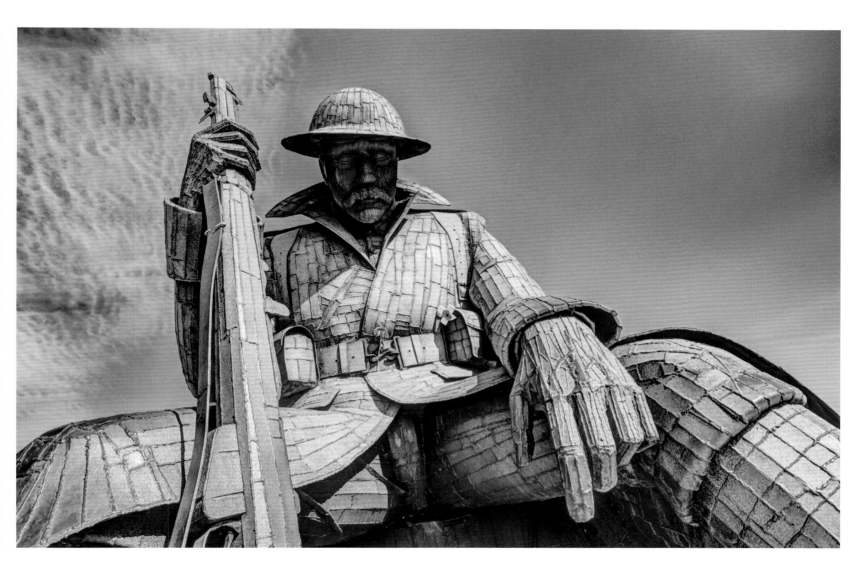

Above Left: There are many ways to tone map an HDR image. Dedicated HDR software, such as Photomatix Pro, generally offers presets that are a useful starting point.

Above: HDR imagery with heavily saturated color and high contrast is less commonly seen than it once was. This is mainly due to the ubiquity of the technique when it first came to popular attention—thanks to social media, a distinctive visual style like HDR can quickly become tired and clichéd. There's still a place for HDR, but using it sparingly and in interesting ways is highly recommended.

Focal length: 20mm

Three blended exposures

ISO: 100

Black & White

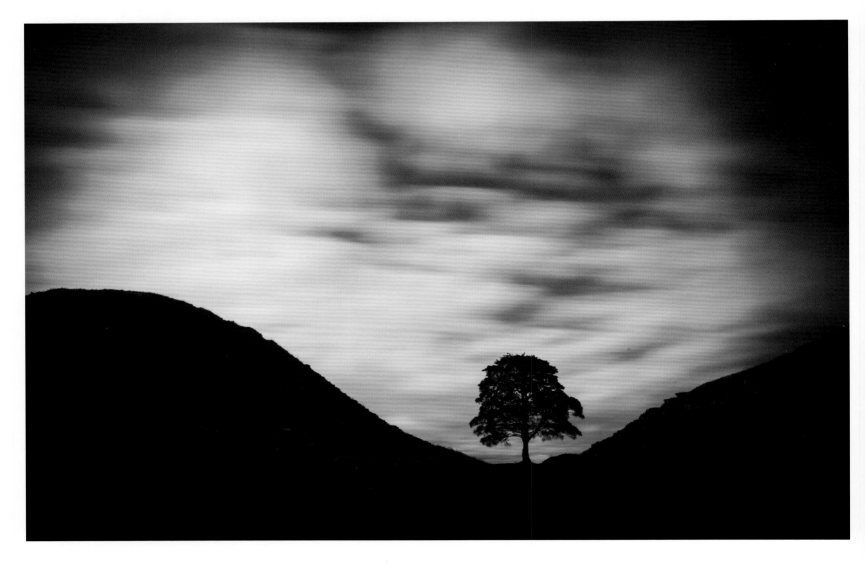

Black-and-white photography has a timeless quality that will arguably never date. Although most digital cameras can be set to shoot in black and white through the picture parameter options, greater control is achieved when you convert color photographs to black and white in postproduction.

As there is no color information, a black-and-white image depends entirely on its tonal range for impact. Ultimately you may decide that your black-and-white image benefits from a compressed tonal range (increasing contrast), but that doesn't mean you should increase contrast at the time of shooting. The more image information you can retain in both the highlights and shadows at the exposure stage, the more creative options you will have during the conversion process.

Above: Black-and-white imagery is arguably better suited to effects such as extremely long exposures than color photography. However, pre-visualization is the key, even if you initially shoot in color.

Focal length: 24mm

Aperture: f/22

Shutter speed: 30 sec. (with 6-stop ND filter)

ISO: 100

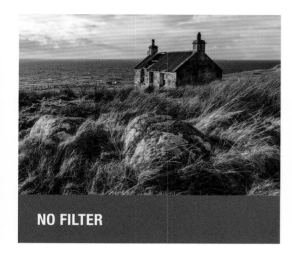

NO FILTER

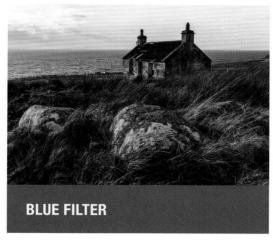

BLUE FILTER

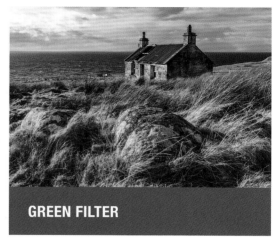

GREEN FILTER

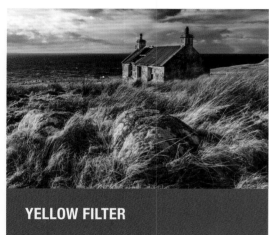

YELLOW FILTER

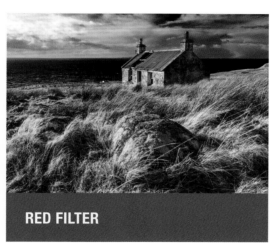

RED FILTER

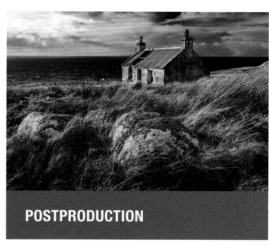

POSTPRODUCTION

Filtration

Using colored filters is often necessary when creating black-and-white images, as it helps to separate colors tonally in the final photograph. Whether you use physical filters in front of the lens, an in-camera filter option, or simulate their use in postproduction depends on your camera and how it is set. If you shoot black-and-white film then physical filters will be needed, but if you set your digital camera to shoot black-and-white JPEGs you could either use filters or an in-camera option that simulates their use electronically. If you shoot Raw, your camera will always record a color image, even though selecting a monochrome picture parameter will show you a black-and-white result

Above & Right: The filter color you choose will depend on the colors that you want to separate tonally. Typically, yellow, red, and green filters are useful for landscape photography, while green filters are useful for portraiture. Blue filters are rarely used.

Focal length: 35mm
Aperture: f/16
Shutter speed: 1/25 sec. (with polarizing filter)
ISO: 100

in playback. The color image can be converted to black and white in postproduction, giving you greater control over how the various colors in the image are converted to shades of gray.

Above: One of the appealing aspects of black-and-white photography is that images can be processed less literally than those in color. This shot has been given a subtle split-toned effect of cool shadows and warm highlights. Black and white is not an excuse to be sloppy when shooting, though—a well-exposed shot will give far more latitude for adjustment than one that is poorly exposed.

Focal length: 55mm

Aperture: f/7.1

Shutter speed: 1/9 sec.

ISO: 200

Above: Color can be visually distracting. By removing the color from this shot the central idea of a figure slyly reading as a letter is written has been made more obvious.

Focal length: 50mm

Aperture: f/2.8

Shutter speed: 1/100 sec.

ISO: 500

Above: Images that rely on color for impact generally make poor candidates for black-and-white conversion. Color images with a limited color palette, but a wide contrast range, are usually a better option.

Focal length: 80mm

Aperture: f/9

Shutter speed: 1/50 sec.

ISO: 100

Glossary

Aberration An imperfection in a photograph, usually caused by the optics of a lens.

AEL (automatic exposure lock) A camera control that locks in the exposure value, allowing a scene to be recomposed.

Angle of view The area of a scene that a lens takes in, measured in degrees.

Aperture The opening in a camera lens through which light passes to expose the sensor. The relative size of the aperture is denoted by f/stops.

Autofocus (AF) A reliable through-the-lens focusing system allowing accurate focus without the photographer manually turning the lens.

Bracketing Taking a series of identical pictures, changing only the exposure, usually in ⅓-, ½-, or 1-stop increments.

Buffer The in-camera memory of a digital camera.

Camera shake Image fault caused by camera movement during exposure.

Center-weighted metering A metering pattern that determines the exposure by placing importance on the light meter reading at the center of the frame.

Chromatic aberration The inability of a lens to bring spectrum colors into focus at a single point.

Color temperature The color of a light source expressed in degrees Kelvin (K).

Compression The process by which digital files are reduced in size. Compression can retain all the information in the file (lossless compression), or "lose" data for greater levels of file-size reduction (lossy compression).

Contrast The range between the highlight and shadow areas of a photo, or a marked difference in illumination between colors or adjacent areas.

Depth of field (DOF) The amount of an images that appears acceptably sharp. This is controlled primarily by the aperture: the smaller the aperture, the greater the depth of field.

Digital sensor A microchip consisting of a grid of millions of light-sensitive cells. The more cells, the greater the number of pixels and the higher the resolution of the final image. The two most commonly used types of digital sensor are CCD (Charge-Coupled Device) and CMOS (Complementary Metal-Oxide Semi-conductor).

Diopter Unit expressing the power of a lens.

Distortion A lens fault that causes what should be straight lines in an image to bow outward from the center (referred to as barrel distortion) or inward (referred to as pincushion distortion).

dpi (dots per inch) Measure of the resolution of a printer or scanner. The more dots per inch, the higher the resolution.

DPOF Digital Print Order Format.

Dynamic range The ability of the camera's sensor to capture a full range of shadows and highlights.

Evaluative metering A metering system where light reflected from multiple subject areas is calculated based on algorithms.

Exposure The amount of light allowed to hit the digital sensor, controlled by aperture, shutter speed, and ISO. Also, the act of taking a photograph, as in "making an exposure."

Exposure compensation A control that allows intentional over- or underexposure.

Fill-in flash Flash combined with daylight in an exposure. Used with naturally backlit or harshly side-lit or top-lit subjects to prevent silhouettes forming, or to add extra light to the shadow areas of a well-lit scene.

Filter A piece of colored or coated glass, or plastic, placed in front of the lens.

Focal length The distance, usually in millimeters, from the optical center of a lens to its focal point.

fps (frames per second) A measure of the time needed for a digital camera to process one photograph and be ready to shoot the next.

f/stop Number assigned to a particular lens aperture. Wide apertures are denoted by small numbers (such as f/1.8 and f/2.8), while small apertures are denoted by large numbers (such as f/16 and f/22).

HDR (High Dynamic Range) A technique that increases the dynamic range of a photograph by merging multiple shots taken at different exposure settings.

Highlights The brightest part of an image.

Histogram A graph representing the distribution of tones in a photograph.

Hotshoe An accessory shoe with electrical contacts that allows synchronization between a camera and a flash.

Hotspot A light area with a loss of detail in the highlights. This is a common problem in flash photography.

Incident light reading Meter reading based on the light falling onto the subject.

Interpolation A way of increasing the file size of a digital image by adding pixels, thereby increasing its resolution.

ISO The sensitivity of the digital sensor measured in terms equivalent to the ISO rating of a film.

JPEG (Joint Photographic Experts Group) JPEG compression can reduce file sizes to about 5% of their original size, but uses a lossy compression system that degrades image quality.

LCD (Liquid crystal display) The flat screen on a digital camera that allows the user to compose and review digital images.

Macro A term used to describe close focusing and the close-focusing ability of a lens.

Megapixel One million pixels is equal to one megapixel.

Memory card A removable storage device for digital cameras.

Metering Act of measuring the amount of light falling on a scene to determine the required exposure.

Mirrorless Common name given to a camera that doesn't have a reflex mirror (*see* SLR). The photographer views a live image streamed from the digital sensor to an LCD.

Monochrome A synonym for black-and-white photography.

Noise Interference visible in a digital image caused by stray electrical signals during exposure.

Overexposure A result of allowing too much light to reach the digital sensor during exposure. Typically, the highlights in an overexposed image will be burnt out to pure white and the shadows will appear unnaturally bright.

PictBridge The industry standard for sending information directly from a camera to a printer, without the need for a computer.

Pixel Short for "picture element"—the smallest bit of information in a digital photograph.

Predictive autofocus An AF system that can continuously track a moving subject.

Raw The file format in which the raw data from the sensor is stored without permanent alteration being made.

Red-eye reduction A system that causes the pupils of a subject's eyes to shrink, by shining a light prior to taking the main flash picture.

Remote switch A device used to trigger the shutter of the camera from a distance, to help minimize camera shake. Also known as a "cable release" or "remote release."

Resolution The number of pixels used to capture or display a photo.

RGB (Red, Green, Blue) Computers and other digital devices understand color information as combinations of red, green, and blue.

Rule of Thirds A rule of composition that places the key elements of a picture at points along imagined lines that divide the frame into thirds, both vertically and horizontally.

Shadows The darkest part of an image.

Shutter The mechanism that controls the amount of light reaching the sensor, by opening and closing.

SLR (Single Lens Reflex) A camera that directs the image projected through the lens to the viewfinder using a reflex mirror.

Soft proofing Using software to mimic on screen how an image will look once output to another imaging device. Typically this will be a printer.

Spot metering A metering pattern that places importance on the intensity of light reflected by a very small portion of the scene, either at the center of the frame or linked to a focus point.

Teleconverter A supplementary lens that is fitted between the camera body and lens, increasing its effective focal length.

Telephoto A lens with a large focal length and a narrow angle of view.

TIFF (Tagged Image File Format) A universal file format supported by virtually all relevant software applications. TIFFs are uncompressed digital files.

TTL (Through The Lens) metering A metering system built into the camera that measures light passing through the lens at the time of shooting.

Underexposure The result of allowing too little light to reach the digital sensor during exposure. Typically, the highlights in an underexposed image will appear muddy and the shadows will be dense and lacking in detail.

USB (Universal Serial Bus) A data transfer standard used by most cameras when connecting to a computer.

Viewfinder An optical system used for composing and sometimes for focusing the subject.

White balance A function that allows the correct color balance to be recorded for any given lighting situation.

Wide-angle lens A lens with a short focal length and, consequently, a wide angle of view.

Zoom A lens with a variable focal length.

Useful Web Sites

Photographers

David Taylor www.davidtaylorphotography.co.uk

General

Digital Photography Review www.dpreview.com
On Landscape www.onlandscape.co.uk

Photographic Equipment

Canon www.canon.com
Fujifilm www.fujifilm.com
Nikon www.nikon.com
Olympus www.olympus-global.com
Panasonic www.panasonic.net
Ricoh/Pentax www.ricoh-imaging.com
Sigma www.sigma-photo.com
Sony www.sony.com
Tamron www.tamron.com
Tokina www.tokinalens.com

Photography Publications

AE Publications www.ammonitepress.com
Photographer's Institute Press www.pipress.com
Black & White Photography Magazine www.thegmcgroup.com
Outdoor Photography Magazine www.thegmcgroup.com

Printing

Epson www.epson.com
Hahnemühle www.hahnemuehle.de
Harman www.harman-inkjet.com
HP www.hp.com
Ilford www.ilford.com
Kodak www.kodak.com
Lexmark www.lexmark.com
Lyson www.lyson.com
Marrutt www.marrutt.com

Software & Actions

Adobe www.adobe.com
AlienSkin www.alienskin.com
Apple www.apple.com
Corel www.corel.com
DxO www.dxo.com
Phase One www.phaseone.com
Photomatix www.hdrsoft.com
PhotoPills www.photopills.com

Index

Acknowledgments

Writing a book means spending huge amounts of time desperately trying to wrangle thousands of words into some sort of coherent order. For this book I had the sterling support of Chris Gatcum, whose editorship means that the book probably makes far more sense than it would otherwise; I'd like to thank Chris and the fine folk at Ammonite Press for their help in producing this book. I'd also like to thank Richard Wiles for commissioning the book, Sue and Brian Brown, my wife Tania, and, last but not least, my parents, Bill and Carol Taylor, who bought me my first camera some 30-odd years ago. This book is dedicated to both of them.

AMMONITE
PRESS

To place an order, or request a catalog, contact:
Ammonite Press
AE Publications Ltd, 166 High Street, Lewes, East Sussex, BN7 1XU, United Kingdom
Tel: +44 (0)1273 488006
www.ammonitepress.com